P9-EML-450

# Creative Photography Lab

© 2013 by Quarry Books
Text © 2013 Steve and Carla Sonheim
Photography © 2013 Steve Sonheim

First published in the United States of America in 2013 by
Quarry Books, a member of
Quayside Publishing Group
100 Cummings Center
Suite 406-L
Beverly, Massachusetts 01915-6101
Telephone: (978) 282-9590
Fax: (978) 283-2742
www.quarrybooks.com
Visit www.Craftside.Typepad.com for a behind-the-scenes peek at our crafty world!

All rights reserved. No part of this book may be reproduced in any form without written permission of the copyright owners. All images in this book have been reproduced with the knowledge and prior consent of the artists concerned, and no responsibility is accepted by the producer, publisher, or printer for any infringement of copyright or otherwise, arising from the contents of this publication. Every effort has been made to ensure that credits accurately comply with information supplied. We apologize for any inaccuracies that may have occurred and will resolve inaccurate or missing information in a subsequent reprinting of the book.

10 9 8 7 6 5 4 3 2 1

ISBN: 978-1-59253-832-4

Digital edition published in 2013
eISBN: 978-1-61058-930-7

Library of Congress Cataloging-in-Publication Data available

Book Layout: *tabula rasa* graphic design, www.trgraphicdesign.com
Series Design: John Hall Design Group, www.johnhalldesign.com
Photography: All photos by Steve Sonheim except where indicated
Cover Design: Leigh Ring

Printed in China

# Creative Photograpy Lab

## 52 Fun Exercises for Developing Self-Expression with Your Camera

Steve Sonheim

with Carla Sonheim

**Quarry Books**
100 Cummings Center, Suite 406L
Beverly, MA 01915

quarrybooks.com • craftside.typepad.com

# Contents

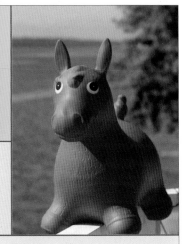

Introduction **7**

## UNIT 1

### Fire Away 20

Lab 1: Smartphone 30/30 **22**
Lab 2: Blink! **24**
Lab 3: Blink! Revisited **26**
Lab 4: Shot in the Dark **28**
Lab 5: Hocus Focus **30**
Lab 6: Walk with a Blind Camera **32**
Lab 7: 100 Shots **34**
Lab 8: Spin Like a Top **36**
Lab 9: Mixed-Media Project with Carla:
Textured Photo Flags **38**

## UNIT 2

### Seeing the Light 40

Lab 10: Plus and Minus **42**
Lab 11: Light and Dark **44**
Lab 12: Shadows in Black and White **46**
Lab 13: Backlight **48**
Lab 14: Hunter **50**
Lab 15: Roaming Pony **52**
Lab 16: Same But Different **54**
Lab 17: On White **56**
Lab 18: Reflection **58**
Lab 19: Mixed-Media Project with Carla:
Cereal Box Photo Paintings **60**

## UNIT 3

### Fellow Travelers 64

Lab 20: Cat and Mouse **66**
Lab 21: Make Believe **68**
Lab 22: Faceless **70**
Lab 23: Window Light **72**
Lab 24: Animal Parts **74**
Lab 25: Tension **76**
Lab 26: Bugs **78**
Lab 27: Stranger Danger **80**
Lab 28: Moody Portrait **82**
Lab 29: Mixed-Media Project with Carla:
Put a Fairy on It! **84**

## UNIT 4

### Talking to Yourself 88

Lab 30: Camera-to-Work Day **90**
Lab 31: Hate It **92**
Lab 32: Step by Step **94**
Lab 33: Self Portrait **96**
Lab 34: Observation Friday **98**
Lab 35: Collection **100**
Lab 36: Document **102**
Lab 37: Mixed-Media Project with Carla:
Mini Photo Journal **104**

## UNIT 5

## Finger Painting 106

**Lab 38:** Blur **108**

**Lab 39:** Squiggle Drawing **110**

**Lab 40:** Head Like a Hole **112**

**Lab 41:** Night Vision **114**

**Lab 42:** Light Painting **116**

**Lab 43:** Bokeh **118**

**Lab 44:** Mixed-Media Project with Carla:
Dots **120**

## UNIT 6

## Deeper Waters 122

**Lab 45:** Splat! **124**

**Lab 46:** Emulate Nonphotographs **126**

**Lab 47:** Picture in Picture **128**

**Lab 48:** Seriously? **130**

**Lab 49:** Abstraction **132**

**Lab 50:** 25 Strangers **134**

**Lab 51:** Lose Yourself **136**

**Lab 52:** Mixed-Media Project with Carla:
Abstract Painting **138**

Glossary of Terms **140**

Contributing Artists **142**

Acknowledgments **142**

About the Authors **143**

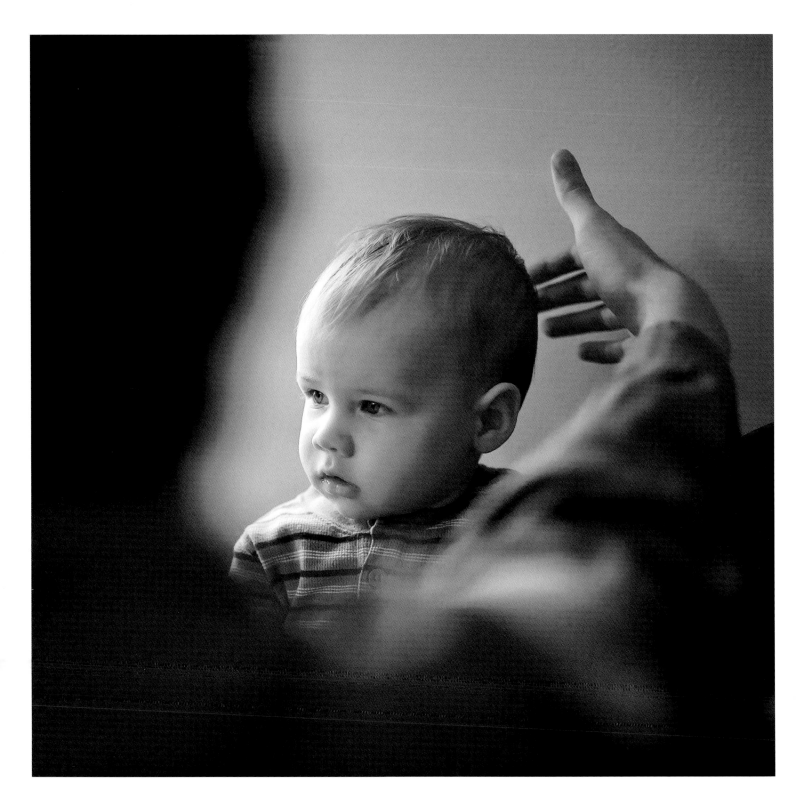

# Introduction

**TAKING A PICTURE IS A SIGNIFICANT EVENT.** You are enacting a creation—something unique that communicates feelings and ideas. A photo is a moment of your life with all the evidence of an impulse and a series of decisions. Yet we look at and take so many photos, we can forget that significance.

The first objective of this book is to help you put more of yourself into your images. This means stepping away from some of the traditional rules and techniques. It involves being a bit silly, learning to relax, and having fun making shots.

The expression of thoughts and feelings through photography is not only possible but is important for a balanced creative mind and a balanced culture. Toward that end, each assignment will give you a specific prompt to push you out the door. Think of the assignments as the starting block but not the race. Run where your imagination and discoveries lead.

The second objective is to help you better understand and use the main tool—your camera. Toward that end, most assignments will have a creative and a technical aspect to them. The creative push is the most important thing, however. You can take what you want and need from the technical prompts, but don't let it bog down your freedom.

When you are learning to drive, you spend most of your brain energy thinking about the car and how to control it. But once you figure it out and get good at it, you can forget how the car works and start thinking about all the places you can go.

By simply pushing the button on a digital camera, you can take pictures, even great pictures, and you don't have to go beyond that if you don't want to.

A camera only does two things:
- Focuses light onto film or sensor
- Controls the amount of light

However, the more you know about your tools, the more you can make decisions about what your images will look like. All the little decisions we make when we take a photograph reflect our personality and personal vision, and that is what is most exciting about photography or any art.

These decisions, or steps, are obvious in painting or sculpture. In picture taking, however, we have this sophisticated device between our eye and the subject. How do you know what you decided and what the camera did on its own? That's why we say things like, "I hope the shot turns out;" the results are largely out of our hands.

To bring more of ourselves into our shots, we need a basic understanding of the camera. We don't need to know exactly how it works, but we do need to know exactly what it does.

## The Camera

Any camera does only two things: focuses an image onto the film or sensor and controls the amount of light that is being focused.

Digital cameras—from DSLRs to smartphones—do these two tasks automatically and do them quite well. If you point your camera at something and push the button, you're going to get a decent image. The more advanced cameras give us more control and more ways to customize the control. But the tasks are the same for an ancient film camera that doesn't even have batteries and the most sophisticated DSLR: focus and exposure.

## Focus

Focus is pretty straightforward; the lens moves in or out to bring your subject into focus. The most basic point-and-shoot (PAS) cameras have a simple way of focusing—place the little blinking square on what your want in focus and snap the shot. Advanced DSLRs give options for tracking moving objects, multiple focus points, and face recognition. Your owner's manual is the best place for information and will present it better than I can here. Experiment with the options your camera offers, pick something that works for you, and practice with it.

*The goal isn't to learn how to take pictures like a professional, but to learn how to take pictures like you!*

## Exposure

Exposure is a little more difficult to get your head around. So to start, we need to make a clear distinction between exposure and lighting.

**Exposure** refers to the overall *quantity* of light it takes to make a photograph. Our eyes are constantly adjusting to the brightness of the world around us so we can see. The camera does the same thing, and when we talk about exposure, we are talking about the adjustments the camera makes to adapt to the situation we are in.

**Lighting**, on the other hand, refers to the *quality* of the light in our pictures. Here we are talking about the direction, color, and softness of the light falling on our scene. It's important to understand that the only thing the camera settings can affect is exposure, and good exposure doesn't necessarily mean good lighting. Good light in photos (outside of the studio) comes from nature and capturing it involves looking, learning, waiting, and moving around—nothing to do with the camera.

To illustrate the concept, here is a little fairy tale.

### Bread Baking Metaphor

Exposure is like the time and temperature that we set the oven. If we get it right, the bread will be properly baked. Lighting, on the other hand, is like all the ingredients that go into the dough that give it taste, texture, aroma, and color.

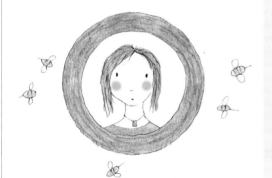

### F-Stops and the Bees

Once upon a time, there was a princess locked in a tower with one round window. Outside the tower was a swarm of magic bees. She discovered that if she opened the window and let in a group of exactly 100 bees each day that they would make a pot of honey for her. She also discovered that the window was magic and could change its size. The trick was to let the exact number of bees in at a time, but the number of bees buzzing around outside kept changing. For instance, in the evening there were fewer bees, so the window would stay open longer, or open wider, or both. During the day, there were lots of bees outside so the window would stay small and close quickly. Sometimes the princess would like to stand by the window and watch the bees in the evening, so she would make the window small but leave it open for a very long time to let in enough bees.

*Exposure determines whether the overall photo is too light or too dark.*

*The lighting in the image determines the mood and feeling.*

*Aperture*

*Shutter speed*

## Aperture and Shutter Speed

Like the princess and her bees, your camera has to let in the same amount of light every time you take a picture. And because the amount of light outside is always changing, the camera must control how many "bees" get in. Like the tower window, the camera has two ways of doing this. **Aperture** is like the size of the window and **shutter speed** is how long it is open.

Every time you press the button, the camera quickly measures the light and picks a combination of shutter speed and aperture to let the right amount of light in. Your exposure is the combination of these two controls.

Aperture settings follow this string of numbers: f/2.8, f/4, f/5.6, f/8, f/11, f/16, and f/22; you only need to know that the smaller the number, the larger the opening (window).

Shutter speed settings are the fractions of a second that the shutter (window) is open: 1/4, 1/8, 1/15, 1/30, 1/60, 1/125, and 1/250.

So back to the bees: To get 100 bees, you could open the window to f/8 and hold it open for 1/30 of a second. Or you could open it to f/11 (smaller) and hold it open for 1/15 of a second (longer). Any combination works as long as you make the same number of steps in opposite directions.

To keep it simple, we don't ever really talk about how much light is falling on a scene or how many bees are buzzing around outside. Rather, the camera just gives us a combination of size and time, such as f/8 at 1/30. The camera measures the light to make that determination, but all we see is the suggested exposure.

Shutter speed and aperture work together to control the brightness of our images so we get a well-exposed shot for any kind of situation. I call them "The Two Amigos."

In manual mode, we can change the shutter speed and aperture as long as we change both the same amount. In auto mode, all this happens behind the scenes, and we don't even have to care.

Shutter speed and aperture (The Two Amigos) both have an affect on how our images look beyond just brightness. But before we talk about that, we have one more exposure component to talk about: ISO, "The Third Amigo."

## ISO

Think about ISO like printer paper. You can use lightweight, less expensive paper that prints faster with less ink, but you get a lower quality result. Or you can use a heavy, coated paper that takes longer to print but yields a much better print. In either case, you need to tell the printer which paper (ISO) you are using so it can put out the right amount of ink (exposure).

Low ISO settings will give you the best image but require more light. High ISO will produce images with more noise or grain but need less light.

Almost all cameras have an auto ISO feature that works in the background and keeps the ISO setting as low as possible. If there is not enough light to maintain a good shutter speed, the camera will start to increase the ISO. You don't need to worry about it unless you are concerned about grainy or noisy images.

## Motion Blur and Depth of Field

So, we know that ISO determines how much light is needed for a photo and also affects the graininess of the image. As I mentioned earlier, shutter speed and aperture also affect the look of an image and here's how.

**Motion Blur**: Anything, including the camera, that is moving during a shot will cause a blur if the shutter speed is too slow. A few general guidelines are all you need to remember: A handheld camera will blur below 1/60, sports and kids blur around 1/250, and race cars blur at 1/4000.

**Depth of Field**: Aperture controls exposure and depth of field. To demonstrate this, hold your hand close to your face and focus with your eyes on your fingers. Now focus on the room behind your hand. You can't keep both your hand and the room in focus, which means your eyes have very shallow depth of field. We can't focus on something close and something far at the same time. We don't notice this because our eyes focus so fast that anything we look at is instantly sharp.

A lens, on the other hand, can hold focus from near to far if you make the aperture very small. A pinhole camera works without a lens because the hole is so small that everything is sort of in focus. I say sort of because even at really small apertures, only the thing you actually focus on is perfectly sharp.

Shutter speed, aperture, and ISO, *The Three Amigos*, all work together. ISO sets the ground rules by determining how much light is needed to make a photo of a certain clarity. Aperture and shutter speed then work together to deliver that exact amount of light.

**DSLRs** have full-manual modes where you set ISO. Once you set the ISO, the camera will meter the light in your scene and indicate when you have matched an appropriate aperture and shutter combination. Point-and-shoot cameras permit varying degrees of manual operation. Some allow total control; some allow you to set one or two of the amigos and automatically set the third. Smartphones do it all automatically.

As you "stop down" the lens by using a small aperture, more of the image comes into focus both behind and in front of your subject:

**Small aperture** (large number) = more depth of field
**Large aperture** (small number) = shallow depth of field

So *The Three Amigos*, ISO, shutter speed, and aperture, all work together to make a perfectly exposed image in any situation from a sunny beach to a dark pool hall, and they each have their tradeoffs:

**ISO** = image clarity, or graininess
**shutter speed** = blur
**aperture** = depth of field

## Program Modes

Program modes are designed to give the camera a hint about what you are shooting so it can make a good guess at the best setting for each of *The Three Amigos*: ISO, shutter speed, and aperture. You can't go too far wrong on a point-and-shoot camera by just choosing the appropriate mode for your subject. DSLRs also have some good preprogrammed modes, but it takes a little more owner-manual time to understand what they do. The main thing to remember is that the modes and settings are just choosing the best characteristics of *The Three Amigos* to fit your situation.

For example, if you have an action or sports mode, the priorities will be something like this:

**First priority**: Fast shutter speed to prevent blur

**Second priority**: Small aperture for depth of field—
moving objects are hard to keep in focus

**Third priority**: Low ISO for clear images

On a sunny day, all three priorities can be met, but as it gets darker, the camera will first increase the ISO, and then it will start opening the aperture, sacrificing focus to maintain shutter speed. If it keeps getting darker, the ISO will go even

*Shallow depth of field means only the exact spot you focus on is sharp.*

*Wide depth of field means that almost everything from foreground to background is relatively in focus.*

*This is a perfect candidate for action mode, as the subject is moving and hard to focus on.*

higher and the aperture will open all the way, and finally the shutter speed will start to drop. If the flash feature is turned on, it will also kick in at some point to try and light the scene.

## Exposure Compensation

Exposure compensation is probably the most useful setting on your camera. Check your owner's manual; it is sometimes called EV override and is like a dimmer switch for your pictures. Dial it up or down to make all your subsequent shots lighter or darker regardless of which mode you are in and without even thinking about *The Three Amigos*.

## Image Quality

Image quality, also called file size or image size, is different from image quality with ISO. This doesn't have anything to do with exposure, it just tells the camera how big you want the photo to be. A bigger file equals a better picture, but fewer shots on the memory card. I recommend setting this at maximum quality and downloading your card more often.

## Flash

For most of these assignments, the flash should be off. Find it in your menu and practice switching it off. If you can't find it, search the Internet for this: "*your camera model*, how do I turn the flash off?"

We leave the flash off because the quality of light it produces is so bad: harsh shadows, flat, very little range, colorless, and it usually ruins the natural light in your scene. Flash is difficult to control, and our objective in this book is to look for and capture great natural light. Use the flash only as a last resort.

## Focus

If your camera will do manual focus, then practice in manual as much as you can. It is a useful skill and will improve your composition. You won't be chasing your subject all over with the focus point and can think more about framing.

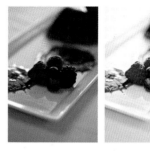

*In this shot, the camera guessed wrong because of the white background. I used exposure compensation and reshot for a lighter image.*

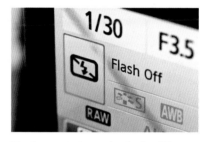

*You'll want to keep the flash off for most of the assignments in this book.*

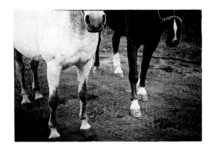

### Tripod

For me, a tripod is the second most important piece of gear. It allows us to shoot scenes at slower shutter speeds without blur. This means more options with ISO and aperture and therefore more creative control. Get a tripod if you don't have one and get the best you can. You will use it a lot, and it won't become outdated or obsolete like a camera will.

### Photo Editing

Digital photography can be divided into to two equal parts: shooting and editing. Often referred to as post-production, the decisions made on the computer are often as involved and time consuming as shooting the image. These later decisions can be very creative and fun, but it is important to recognize the difference in context. When we are out shooting, we are inspired by what we see in the world around us, as well as by what we hear, smell, and feel. When working on the computer, we are inspired by what we see on the screen and the options being offered by the software we are using.

I believe post-production is best used to enhance and carry forward the impulse that created the images in the first place. That is not to say that inspiring art can't be created on the screen, but for the scope of this book, we want to concentrate on the image capture.

As such, you will need a basic editing program that allows you to crop and size images and create collages. There are many options that range from free to thousands of dollars. I suggest choosing something you can grow into.

### Smartphones

With a few exceptions, all the assignments are phone friendly and some are made for it. Each lab will give you a smartphone recommendation.

### Share

We have set up a Flickr site for you to share your images and see what other people around the world are doing with the assignments. Go to Flickr.com and create an account if you don't already have one. Our group is called "Steve Sonheim's Creative Photography Lab."

## A Few Words About Composition and Lighting

We won't spend very much time on the correct way of composing or lighting photos. Granted, there are some helpful rules for composing good images, but they tend toward compositions that look like everyone else's. The goal is to help fill the world with new images that we haven't seen before—not recreate the same old shots.

The same is true for lighting. Principles and rules abound, especially in commercial photography, but for the scope of this book, it's very simple—follow your instincts. Take lots of pictures under different situations and study them. Decide what you like about each shot and experiment with anything that catches your eye. If you see something interesting, then it IS interesting.

*"Consulting the rules of composition before taking a photograph is like consulting the laws of gravity before going for a walk."*
—Edward Weston

# Fire Away

**PHOTOGRAPHY IS ABOUT LEARNING TO SEE** in a new and different way. The first step is to free your picture taking from the constraints of what you think makes a good shot.

These first exercises are like using a sketchbook and doodling to warm you up—something to "get your pencil moving," as Carla says. Set your camera to auto, don't think about the rules, and start clicking.

Let loose and cast a wide net. Venture into situations you don't normally shoot in. Carry your camera around and make a quick capture of everything that catches your eye. Let your first impulse guide you and grab the shot before your analytical mind starts giving orders. Shoot a lot!

Also, take some time to look at what you shot. You don't need to show the images to anyone, organize them into an album, or keep them. Just spend some time with each shot and identify the things that you like, don't like, didn't notice in the scene, or were surprised by.

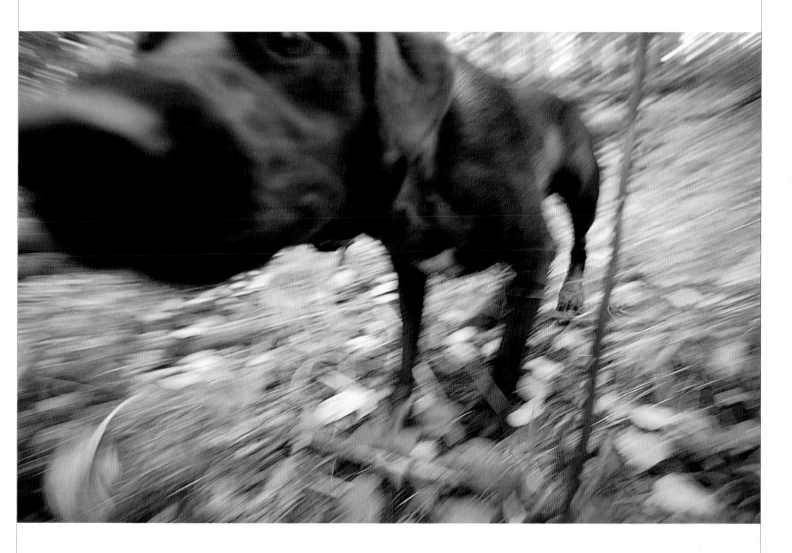

"Your first 10,000 photographs are your worst."
—Henri Cartier-Bresson

# Smartphone 30/30

- smartphone: Your phone is made for this kind of spontaneous shooting.
- DSLR and PAS (point-and-shoot) users: Leave your camera behind and head out with your phone, if it has a camera.

*"Photographers feel guilty that all they do for a living is press a button."*
—Andy Warhol

It's time to go beyond the single snapshot. In this assignment, the objective is to capture an experience by shooting a series of images. Tell a story by taking thirty photos with your smartphone.

## Let's Go!

1. Charge your phone and set a timer for thirty minutes. Then simply take a shot of whatever grabs your attention at one-minute intervals. Don't stop to think, "Will this make a good shot?" Just shoot it.

2. Take a walk, bring someone with you, go alone, sit at your desk ... anything goes.

3. Make a collage of your favorites shots from the day.

### Tip

iPhone users: Check out the app called Photo-Sort to arrange and sort your images on your phone.

A Rainy Walk in the Desert *by Karine M. Swenson.*

# LAB 2 Blink!

Did you ever wish you could just blink and take photographs with your eyes? This assignment is a classic photography exercise that takes the blink a step further.

## Settings

- Leave your camera at home. Instead, you will need a piece of stiff, dark cardboard, a ruler, and a sharp utility knife.

*"I'm always mentally photographing everything as practice."*

—Minor White

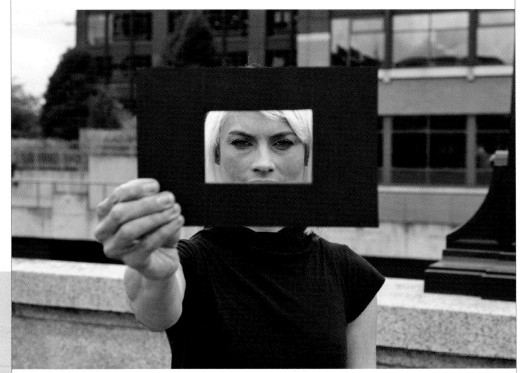

*Change the distance between the frame and your eye to simulate a zoom lens.*

# Let's Go!

1. Cut a piece of dark cardboard into a 6 × 9 inch (15 × 23 cm) rectangle.

2. Carefully cut a 2½ × 4 inch (6.5 × 10 cm) rectangle from the middle.

3. Take your new viewing frame with you all day and make "blink" photographs using your eyes and memory instead of your camera.

4. Hold the frame up to one eye and move it around to compose your picture. Move it in and out to zoom and "blink" your shot.

5. Move slowly as you compose and pay attention to everything in the frame. Try to quickly name every single thing in the shot as a mental exercise. Do you want all those things in there?

6. If it is bright outside, make a really fast blink. If it is dark, make a slow blink. Make a mental note of what your eye was focused on when you blinked. Try some action shots of moving things.

7. Try vertical and horizontal shots.

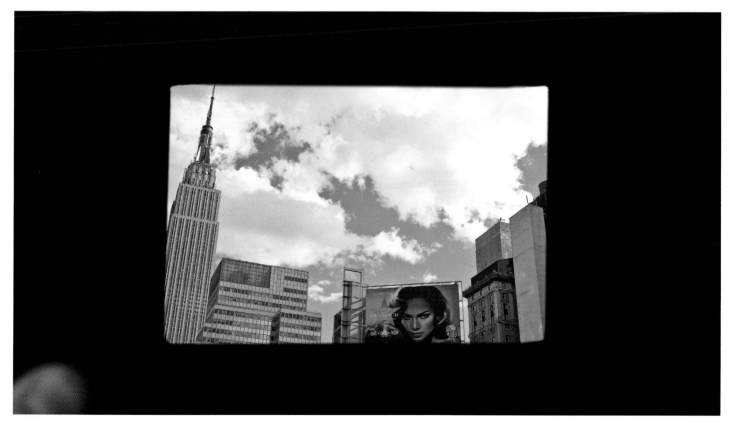

*Use the card to crop out everything you don't want in your shots.*

R0020603471

# LAB 3 Blink! Revisited

## Settings

- flash off
- PAS: Use a snapshot mode.
- DSLR: Use a fully auto mode or snapshot mode that you are comfortable with.
- smartphone: If your phone doesn't have a zoom feature, you may want to crop your images later to fit your blink composition.

*"Photography takes an instant out of time, altering life by holding it still."*

—Dorothea Lange

How many of your blink images do you still have in your head? The challenge for this lab is to try and capture one or two of them with your camera. Grab a fresh memory card so you have plenty of room to take lots of shots.

*Coming back to this "Blink!" shot, I found that even slight changes in the camera position drastically changed the composition.*

*When the boys came around the house with their faces covered in mud, I did a quick blink photo and then ran and grabbed my camera.*

**1.** Revisit the scenes from the "Blink!" assignment (Lab 2).

**2.** Visualize the image in your head.

**3.** Recreate the image in your viewfinder and shoot.

**4.** Work the shot. Keep shooting and changing your framing and camera angle to get exactly what you want in the frame.

**5.** Study the shots. How close did you come to your blink shots? What was the most difficult part to capture?

# Shot in the Dark

One of the great things about photography is the element of surprise. Even when we carefully compose a shot, we can't wait to look at the result. This assignment is about being really surprised because you will be photographing with your eyes closed!

- flash off
- PAS: Use a mode setting such as snapshot.
- DSLR: Use a full auto setting that you are comfortable with.
- smartphone: Hold your phone as far away from your body as possible.

*"My best work is often almost unconscious and occurs ahead of my ability to understand it."*

—Sam Abell

## Let's Go!

1. Find a place where you can easily move around. Study the space for a few minutes and then close your eyes and take twenty shots, keeping your eyes shut the whole time. Try to remember the space and compose each shot in your mind.

2. Get low, get close, get high; try to make each shot as different as possible.

3. Don't look until you have taken all twenty shots. If your results are too light or dark, change your settings and shoot all twenty again; don't peek!

4. Download your images and study each one for a few minutes. Identify the things that you really like and ask yourself this question: Would I have taken the shot with my eyes open?

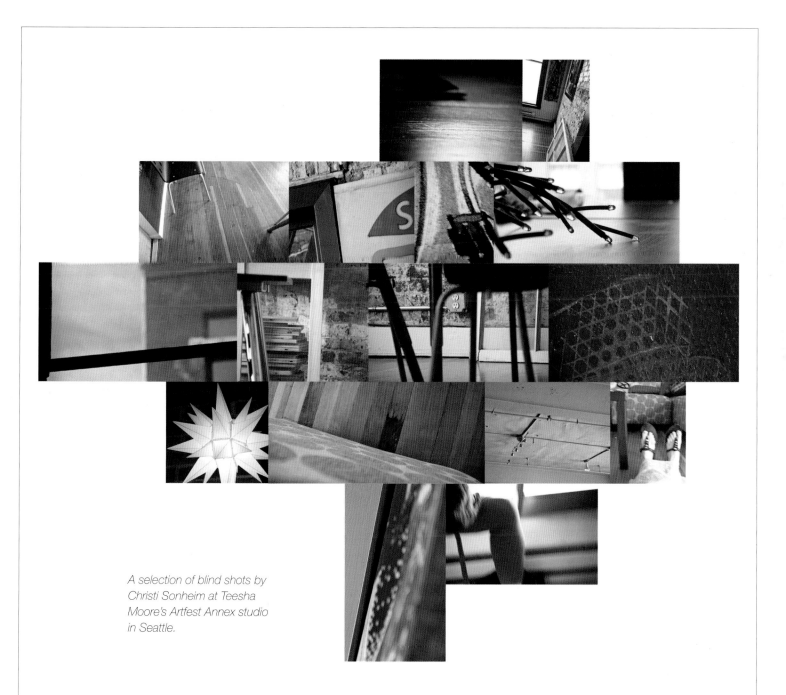

*A selection of blind shots by Christi Sonheim at Teesha Moore's Artfest Annex studio in Seattle.*

# LAB 5 HOCUS FOCUS

- flash off
- PAS: Use a close-up mode.
- DSLR: Use an aperture priority mode that allows you to set your lens to the widest aperture (small numbers such as f/2.4 or f/4). This is critical because you want a very shallow depth of field.
- smartphone: see sidebar

*"Shoot a few scenes out of focus. I want to win the foreign film award."*

—Billy Wilder

Without focus or sharpness in a photograph, we are missing critical information. The details of our subject need to be sharp so we know what we are looking at and can make sense of it. But can you have compelling photographs without focus?

*This photograph by Cheryl Razmus lacks any sharp detail, and yet it tells us a clear story.*

# Let's Go!

*Backlit situations work well to create interesting forms and negative space.*

1. Create an image that is completely out of focus.
2. Switch your lens to manual focus and start looking at things through the camera. Turn the focus ring until everything is blurry and start snapping.
3. Try varying the focus on the same scene.
4. Look for backlit subjects and silhouettes; these make interesting shots.
5. If you can't switch your camera to manual focus, you will have to work around the auto focus by pointing the camera at something very close and then reframing your shot while holding the button part-way down. Almost all auto-focus cameras will allow you to do this. Look in your manual for something called "Focus Lock" or "Auto Focus Hold."

## Smartphone Trick

Here is a way to outsmart your smartphone. Hold the phone so your index finger is in the corner of the shot and then slide the focus indicator so it focuses on your finger. Everything else in the shot should go out of focus. Frame the shot so you can crop your finger out later.

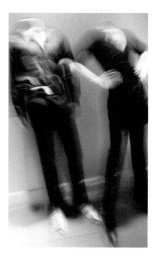

*For this assignment, don't confuse "out of focus" with "motion blur" (Lab 38). This shot of headless mannequins is in focus, but it is blurred because the camera moved during the exposure.*

# LAB 6 Walk with a Blind Camera

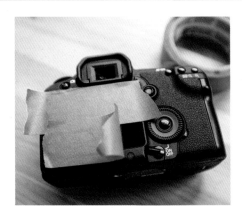

One of the things I miss about the old days of shooting film is the mystery of not knowing what I would get until the film was developed. The instant gratification of digital photography gives us the impression that the camera records reality, making memories before they are even past tense. In this assignment, we separate the act of taking photographs from the act of evaluating photographs.

- PAS and DSLR: Set to auto everything. This is one of the few assignments you can leave your flash on.
- smartphone: Cover your screen but leave a gap for the take-photo button.

*"Discovery consists of seeing what everybody has seen, and thinking what nobody has thought."*

—Albert Szent-Gyorgy Bresson

## Let's Go!

1. Grab your camera and some masking tape. Cover your screen with the tape.

2. Set your camera to auto everything and take one shot every five minutes for an hour. Use a watch or a timer and try to shoot at exactly five-minute intervals.

3. This assignment should be done all at once and works best if you are taking a walk.

4. Try not to plan or think out each shot. Just pick up the camera, shoot, and put it down. Resist the urge to peek; how does this affect your shooting?

5. If you have photo-editing capability, put all twelve images on one page in sequence as a collage. How does the time lag between taking and viewing the shots affect the whole experience?

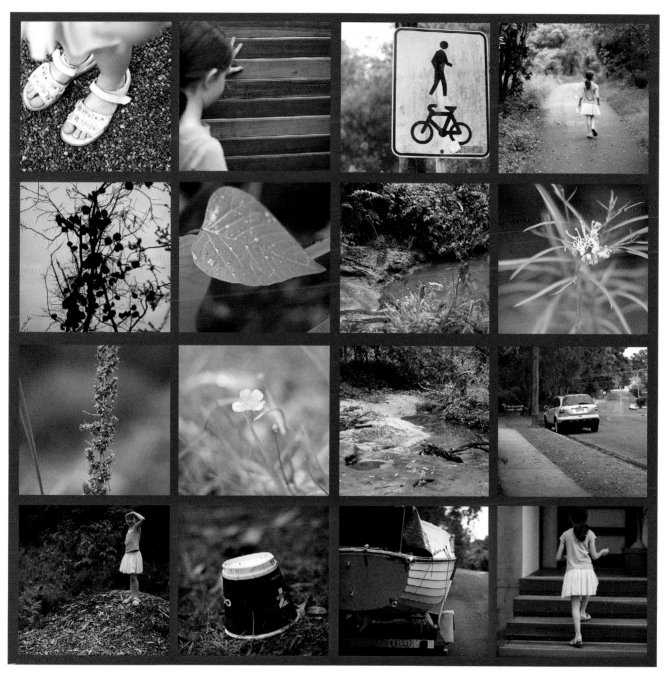

*I really like this relaxed and spontaneous set of images by Natalie Love.*

# 100 Shots

Settings

How many shots does it take to get the great one? Sometimes you can nail it right out of the box; other times it never comes. The trick is to learn the habit of shooting a lot. Not that you might get lucky with the random shot, but because every image you create becomes a part of you and teaches a little something about seeing.

- flash off
- PAS: If your camera has a snapshot mode, use that. Or adjust your mode based on each shot—such as close-up, landscape, and so on.
- DSLR: This is a good time to practice manual mode.
- smartphone: Just fire away!

*"Photograph what makes you happy. It may not have value to anyone else, but it will have value to you."*

—David Allio

*Here are 100 shots by Wesley Sonheim, age 17.*

# Let's Go!

1. Grab your camera and don't come home until you have at least 100 shots.

2. Follow your instincts. If you find something interesting, take 100 shots of that.

3. The important thing is to overcome the inhibition of wasting shots.

4. Think about how much depth of field you want for each shot. If you want one thing in focus with a blurry background, shoot wide open at your biggest aperture setting (smallest number). If you want everything sharp, use a small aperture (big number).

## What Do I Do with All These Shots?

You may feel you have too many shots already. We tend to hold on to photographs like they are precious. Maybe it's a throwback to film days or maybe a compulsion to organize and catalog everything. But it's okay to just take shots and look at them. Think about it as a sketchbook. Don't feel like you have to do anything with your photographs other than just enjoy the experience.

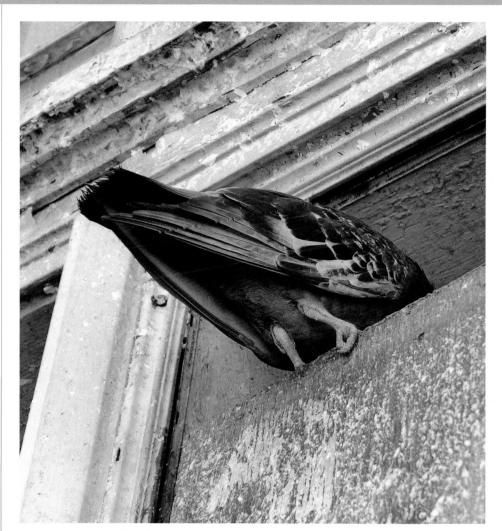

*Is this the best shot? Maybe, but the important thing is to get your shutter finger in shape.*

# Spin Like a Top

If you feel like your head is starting to spin taking all these photographs, here is a fun self portrait to relieve the tension.

## Let's Go!

- PAS: Use a portrait mode and manually set a low ISO.
- DSLR: Use a shutter priority mode. This allows you to pick the shutter speed, and the camera will set the appropriate aperture. Start with 1/8 second and experiment with slower settings.
- smartphone: If your camera has two lenses, you can watch yourself spin!

1. Find an interior or darkish exterior location that has several different lights sources at eye level, such as windows or lamps. Turn off or avoid overhead lights.
2. Set your camera to a low ISO, such as 100. This will force the camera to use a slow shutter speed, which will give you some motion blur.
3. This assignment could be fun in a public place, such as a mall or a café.
4. The area you stand in doesn't need to be dark, but stay out of brightly lit areas.
5. Zoom your lens to wide angle.
6. Hold the camera at arms length, point it at your face, and start shooting as you spin around.
7. If you don't get a good blur in the background, try manually setting a slower shutter speed (1/4, 1/2, 1 second, etc) and close down the aperture (bigger number) to control the exposure.

*"Let tho great world spin for ever down the ringing grooves of change."*

—Alfred Lord Tennyson

## ISO

ISO goes back to the days of film, when you would buy film to match your situation. If you were shooting in a dark situation, you would choose a fast film with a high number, such as 400.

With ISO on the digital camera, you get the best possible image at your lowest ISO setting. However, adjusting your ISO allows you to trade quality of the final image for the ability to shoot in dark situations at a shutter speed that allows you to handhold the camera.

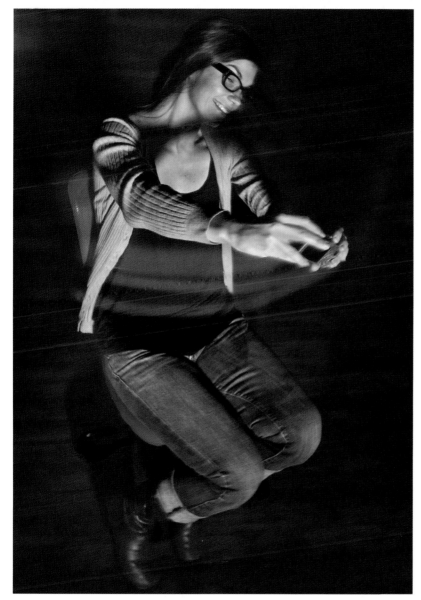

*Take lots of shots and try different expressions. Vary your spin speed and your camera angle. One option is to spin around in a swivel chair.*

# Mixed-Media Project with Carla:
# Textured Photo Flags

## Materials

This project entails going out and photographing textures around you—grasses, sides of buildings, wooden crates—anything graphic or textural that catches your eye. Then we will turn these photographs into a set of pretty banner flags, reminiscent of Tibetan prayer flags.

- 10 digital photographs of textures
- 5 cotton inkjet fabric sheets (such as Jacquard)*
- inkjet printer
- 15' (4.5 m) of string or twine
- scissors
- sewing machine

*Alternatively, you can print your images on t-shirt transfer paper and then iron the images onto white cotton fabric.

*"The artist's world is limit-less. It can be found anywhere, far from where he lives or a few feet away."*

—Paul Strand

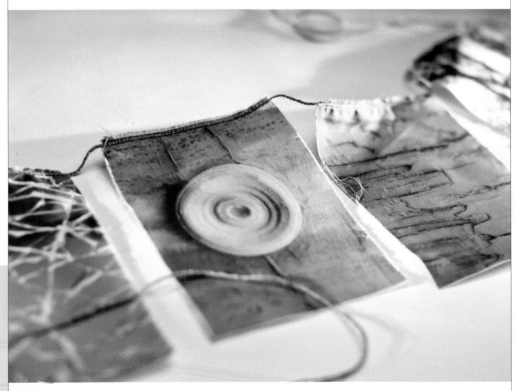

The muted palette of these flags provides a soft and subtle splash of texture and color to your room or porch.

# Let's Go!

**Fig. 1:** *Use a photo-editing program to combine two flags onto one letter-sized file.*

**Fig. 2:** *Pull out some threads on the edges so the flags look more organic.*

**Fig. 3:** *Sew the twine onto either side of the flag.*

1. Shoot (or gather from your photo archives) ten images ot textures. These can include plant matter, walkways, parts of buildings, trees, and so on. Look for designs and patterns in everyday things around you.

2. Size each image to about 4½ × 6 inches (11.5 × 15 cm), place two to a file, and print two "flags" on each piece of 8½ × 11 inch (22 × 28 cm) inkjet fabric paper (fig. 1).

3. Cut out your ten flags using a sharp pair of scissors.

4. Fray the edges of each flag slightly, about ⅟₃₂ inches (0.8 mm). The intention of prayer flags is for them to disintegrate and send our wishes out into the world; this fraying step gives it a head start (fig. 2).

5. On a tabletop, arrange your flags in a sequence that is pleasing to you. Leave a 2 inch (5 cm) gap between each flag. Cut a piece of string or twine to size, allowing at least 3 feet (1 m) of extra string on either end of your flags—roughly 15 feet (4.5 m) total.

6. Set your sewing machine to a fairly wide zigzag stitch. Starting about 3 feet (1 m) from the end, lay the twine across the first flag, and about ⅛ inch (3 mm) from the top edge. Hold everything carefully in place and zigzag over the string, attaching the string to the fabric (fig. 3).

7. When you get to the end of the fabric, continue stitching over the string for about 2 inches (5 cm) before adding your next flag.

8. Repeat until all ten flags are sewn in place, trim threads, and hang!

## Mini Vellum Flags

Instead of printing your images on fabric, print several on vellum paper and then cut into small, irregular-size rectangles. Printing on vellum allows the image to appear on both sides, which works well with smaller flags, which tend to twist and turn when hanging. Stitch together as above, leaving a little more space between the flags if desired.

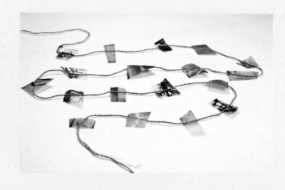

# Seeing the Light

**OUR EYES ADJUST SO WELL** to changes in brightness and color that we don't often think about the quality of light unless we are faced with something spectacular, such as a sunset. We go from one lighting situation to another and need only a moment to adjust. Our cameras are not so flexible. In fact, even the best digital cameras can't record even a tenth of what our eyes can adjust to.

Understanding the limitations of your camera helps you to recognize the situations where great images are possible. This ability comes more through experience than through teaching or technique. Finding good light for shooting is a lifelong learning process of trying things and studying the results. For a photographer, making the most of the available light is usually a physical thing: moving, waiting, and planning.

Getting good exposures, however, is a matter of knowing how to control your camera.

In this chapter, we will work on managing the brightness and color of our images. We will also investigate some specific lighting scenarios to develop our "camera eyes."

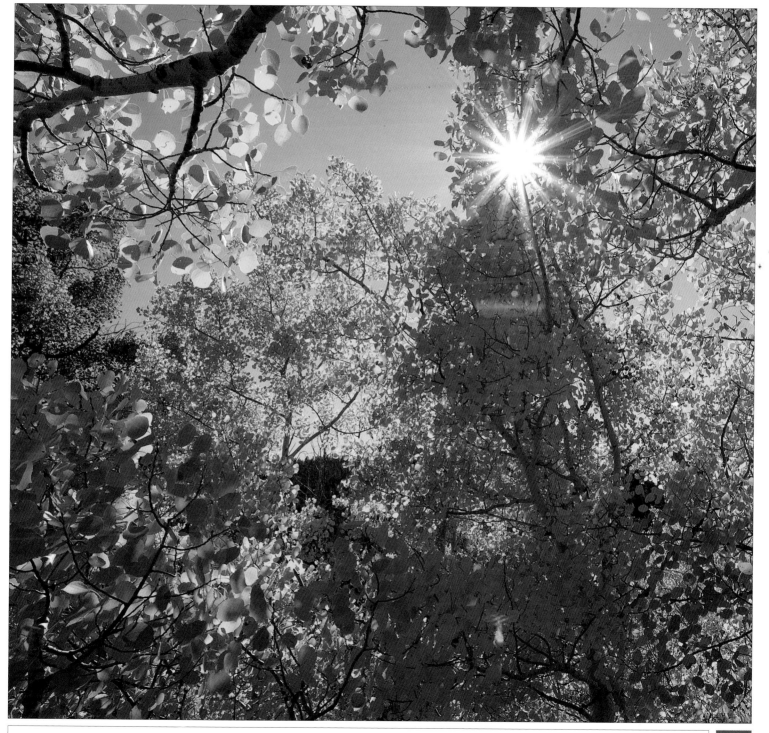

# Plus and Minus

- flash off
- PAS: Almost all cameras have an exposure compensation function, usually found as a menu item under "settings." See the operating manual to find this function on your camera.
- DSLR: Go manual! Pick an aperture and adjust the shutter speed above and below the suggested setting.
- smartphone: This is not the best assignment for the phone unless yours has a brightness control.

*"Photography helps people to see."*

—Berenice Abbott

One of the first questions you have to ask when taking a shot is, "What is the correct exposure?" Our cameras average the light of the scene and calculate a combination of aperture and shutter speed to let in the correct amount of light. In this project, we will explore the relative nature of "correct" and hopefully see that the right setting is an artistic decision, not a technical one.

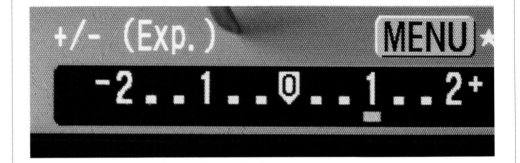

## Let's Go!

1. Pick a subject—it could be anything: a person, landscape, flowers, or still life—and create a bracket of exposures from very underexposed (dark) to very overexposed (bright).
2. Keep the camera and the subject in the same position so you can compare the results.
3. Begin with the recommended exposure or auto setting. Then take a series of shots from two or more stops underexposed to two or more stops overexposed.
4. Study your images. By changing exposure, you can change the mood and reality of a scene.
5. Go back out and do this exercise again will other scones and different subjects, using exposure to create the artistic look you want.

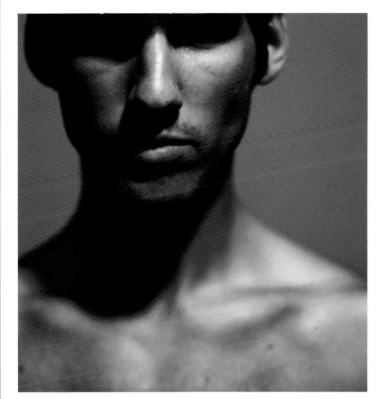
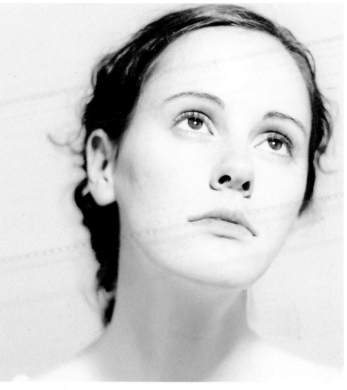

*Both of these shots were taken under the exact same lighting conditions—the only difference was the exposure setting: 2 stops under and 2 stops over, respectively.*

## Bracketing

Bracketing is like throwing a handful of pebbles to be sure you hit your target.

The purpose is to get the exact right exposure by taking many shots of a scene at different settings from light to dark and then picking the best image later.

Use the exposure compensation or EV override feature to make a series of shots from −2.0 to +2.0.

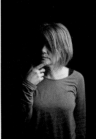
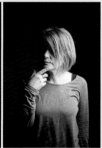

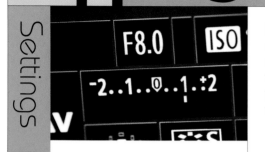

# LAB 11 Light and Dark

Settings

In the last assignment, we messed with reality by making normal things really bright or really dark. But what if your subject is dark and you want it to stay dark? Remember, the camera determines exposure based on the average of all the lights and darks in the scene. This works for most scenes, but not when your subject is mostly white or mostly black (this is why you get gray snow or beach sand when shooting in these mostly white environments). Here we will trick the camera to give us what we want.

- flash off
- PAS: Use your exposure compensation feature.
- DSLR: Use manual mode or exposure compensation.
- smartphone: Use brightness control if your phone has this feature.

*"Every moment of light and dark is a miracle."*

—Walt Whitman

## Let's Go!

Find or create the following shots:

1. A situation where there is a mostly white object against a white background. This could be anything: a white cat on a white rug or someone from Seattle on the white sand in Hawaii.
2. Create the same situation with a dark object and dark background.
3. Photograph each scene using auto or the recommended exposure, and then do a bracket from +2 to –2.
4. What works? Is your white object really white at the normal exposure? Ironically, we have to overexpose the white subject to make it light enough and underexpose when the subject is mostly dark or black.

## 18-Percent Gray

In the early days of photography, someone figured out that a typical landscape scene averages about 18-percent reflectance. That is, if you take all the tones in a black-and-white photo and mixed them together like paint, you end up with middle gray that turns out to be 82 percent white and 18 percent black. (It seems like it should be 50 percent gray, but our eyes tell us that 18 percent is really in the middle.)

The camera doesn't know what you are photographing, and it is programmed to assume that you are taking a picture of a typical scene that averages out to middle (18 percent) gray. Surprisingly, this works most of the time, but it fails if your subject is made up of all bright or dark objects.

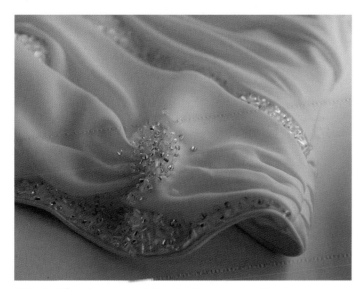

This wedding dress was shot using the exposure the camera determined to be normal and doesn't capture the true whiteness of the dress.

This black suit turns gray using the camera's "normal" exposure.

To get the white look I wanted, I had to overexpose by 1.5 stops.

I wanted the black suit to be black in the photograph, so I underexposed by one full stop.

# Shadows in Black and White

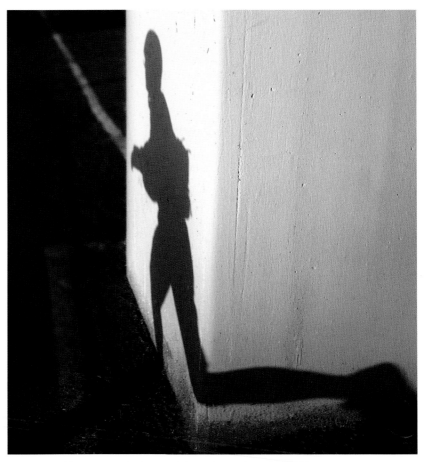

Either early or late on a sunny day, you can find lots of shadows. What I like about shadow photography is you can almost always tell what the subject is even though we see very little detail. I like to compare this to gesture drawing, capturing the essence of the figure with just a simple shape.

- This is a black-and-white assignment, so the first thing is to figure out how to set your camera. Dig out your owner's manual and look up "black-and-white mode."
- flash off
- PAS: Use a portrait mode.
- DSLR: Use an auto mode.
- smartphone: There are some amazing apps for black-and-white photography. I like Black and White Camera for the iPhone.

*"We cast a shadow on something wherever we stand."*

—E. M. Forster

*You are making a portrait of something using only its shadow.*

# Let's Go!

1. Head out early or late on a sunny day or look for a bright street light at night. This assignment should be done outdoors because the lesson is about finding and seeing rather than creating a scene indoors.

2. When you find a shadow that catches your eye, isolate it in the camera frame.

3. Think about conveying the character of the object casting the shadow as a single mass.

4. For an interesting shot, look for places where the shadow is interrupted by other objects, such as when the shadow goes along the ground and then up a wall.

5. Don't rule out moving objects.

## Shooting in Black and White vs. Converting on the Computer

From a technical standpoint, it's better to shoot in color because you have the option of deciding later which version you like better.

However, for this assignment, shoot in black and white if your camera allows. This will help you think in black and white and will direct the artistic decisions you are making.

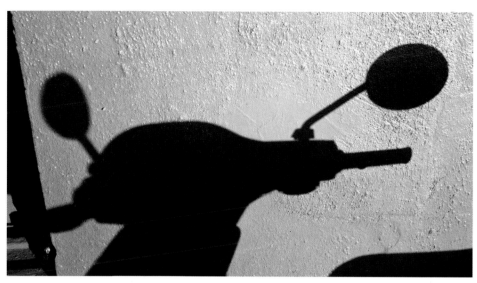

*Is this a scooter or an alien-robot-giraffe?*

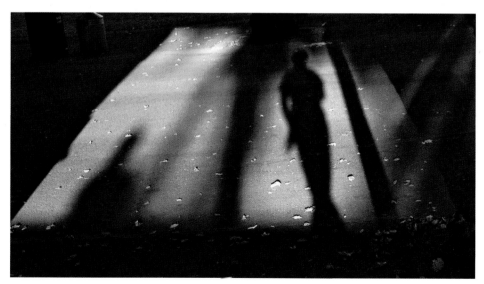

*Shadows are also a fun way to do a self-portrait.*

Settings

Backlighting is when your subject is between your camera and the main light source, sort of like squinting into the sun but in a controlled way. This goes against the conventional wisdom of having the light source shining on your subject from over your shoulder. Backlight is an amazing and useful tool for photographers.

- flash off
- PAS: Use a snapshot mode and exposure compensation.
- DSLR: Use an auto mode but be ready with exposure compensation. The light shining toward the camera may give erroneous readings.
- smartphone: Move your camera around to find a spot that gives the brightness you want.

*"There are two kinds of light—the glow that illuminates, and the glare that obscures."*

—James Thurber

*Backlighting separates the subject from the background by creating a bright edge around it.*

# Let's Go!

1. Go outside with your camera either early or late in the day. The best time is right at sunrise or sunset.

2. Position yourself so you are looking into the sun.

3. Look for subject matter that has a rim of light around the edges or bring someone along and pose them so most of the light is coming from behind them.

4. Looking down from a high viewpoint, such as a hill or balcony, helps to keep the actual light source out of the frame.

5. Shoot fast and shoot a lot, as the perfect lighting will last only a few minutes.

6. Use a telephoto or zoom lens to isolate your subject. This will also keep the light source out of the frame.

7. Bracket your shots to find the exposure that captures what you see.

*Decide how bright you want to make the image. Darker is often more dramatic; adjust using exposure compensation.*

## Backlighting vs. Silhouette

A silhouette is when your subject is in front of a light background and exposed so that the subject is a dark mass. Backlighting on the other hand is when the light source is behind the subject and the subject is being lit, even if only around the edges. The background can be light or dark.

I believe creativity flourishes when constrained. When we see too many options, we become overwhelmed by choice. This exercise gives you very limited parameters, forcing you to find a creative solution.

- flash off
- PAS: Find a setting that allows you to select the aperture or at least a shallow depth of field.
- DSLR: Use an aperture priority mode and set your lens to the widest f-stop for shallow depth of field. Use a medium telephoto lens or zoom setting.
- smartphone: By design, smartphones are built with a fixed aperture that tends to make everything in focus. They're not the best for this lab.

*"Take photographs of fun, have fun."*

—Regina Spektor

*Shooting at your largest aperture (wide open) will give you a very shallow depth of field.*

# Let's Go!

1. Photograph six objects or scenes based on these prompts: orange, careful, tight, range, petite, and grave.

2. Use your very widest aperture (smallest number) to limit depth of field so only a small part of the image is in focus.

3. As always, do lots of test shots.

4. Study your images. Arrange them in a collage. Is there any connection between the objects you chose and your interests and passions?

## Things Affecting Depth of Field

- **F-stop:** The smaller the opening (bigger number), the more your subject will be in focus.

- **Distance from the camera to the subject:** The closer you are to the subject, the shallower the depth of field.

- **Distance from the subject to the background:** Move your subject away from background objects for a shallower DOF.

- **Lens choice:** A wide angle has a much greater DOF, so everything tends to be in focus. Telephoto lenses have shallow DOF, especially for close-ups.

# Roaming Pony

Day Light

Sometimes we take photographs and sometimes we make them. In this assignment, we will take a portable subject to various locations to create a story or just a quirky juxtaposition. We can also use this to study the differences in the quality and color of natural light.

- flash off
- PAS: Use a portrait mode and manual white-balance settings (see your manual).
- DSLR: Use an aperture priority or manual mode to control the depth of field and manual white balance.
- smartphone: This is a great phone assignment because you can be stealthy. Use a small subject and see how many bizarre places you can sneak it into.

*"Don't tell ponies how to do things, tell them what to do and let them surprise you with their results."*

—George S. Patton

*The heart of this assignment is to see what creativity springs from awkwardness, for both you and your subject.*

# Let's Go!

1. Find a goofy or unique object for your subject and take it out to an unlikely environment for a quirky photo shoot.

2. Try several different locations.

3. Create mystery and contrast or tell a story; take risks and be audacious.

4. Use depth of field to blur or sharpen the background.

5. Taking it further: Once you have established your camera angle, background, focus, and exposure, take a series of shots (like a bracket) using each of the different manual white balance settings.

## White Balance

There is no such thing as a pure white light source. Sunlight or daylight is bluish, shade is even bluer, and fluorescent light tends toward green. White balance is a setting that matches the camera's sensitivity to the available light source.

In a fully automatic mode or auto white balance (AWB), your camera will analyze the light and make a correction just like it does with exposure. It usually gets pretty good results, but you can also set the camera manually to match your situation or to make artistic decisions about the color of your images.

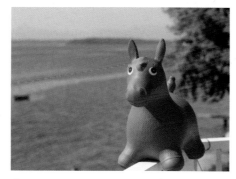

*Camera set to daylight.*

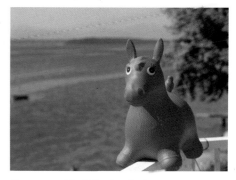

*Camera set to tungsten/indoor.*

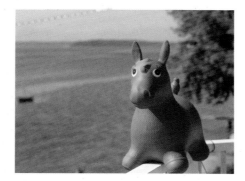

*Camera set to shade.*

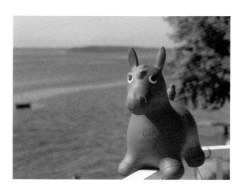

*Camera set to flash.*

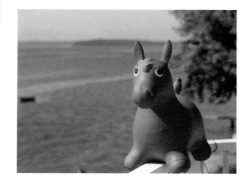

*Camera set to cloudy.*

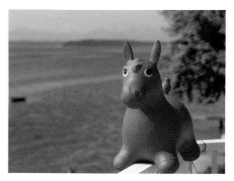

*Camera set to fluorescent.*

Settings

- flash off
- PAS: Use a landscape mode.
- DSLR: Use a tripod, if you have one, for evening and night shots. Auto exposure is fine, but use exposure compensation to make lighter and darker versions.
- smartphone: Just shoot.

*"The painter constructs, the photographer discloses."*
—Susan Sontag

My friend Andy recently got a new camera and he showed me some shots of a mountain range in Colorado. He asked what camera settings he should have used to get better shots. I told him the settings were fine. What he really needed to do was wait a few hours until the sun was lower and maybe hike to the other side of the valley.

Good photography is sometimes about control—posing the subject, lighting the subject, and creating the environment—but some subjects can't be posed or lit. The task then becomes scouting, testing, and coming back to the subject at different times.

*There are several good apps for helping you determine when and where the sun will set. This one is called Sunrise, Sunset and is free on iTunes.*

## Let's Go!

1. Find one of the following: A city skyline, a mountain, a statue, a large piece of earth-moving equipment, or a public building.

2. Find a good point of view and take some shots. Then return to the same location at a different time and take more shots. Do this for as many different times of day and weather as possible: noon, sunset, sunrise, overcast, and full moon.

3. You can spread this assignment over several days or even seasons.

4. Study your shots and decide what you like and don't like. Getting the great shot is sometimes about waiting until nature puts all the pieces together.

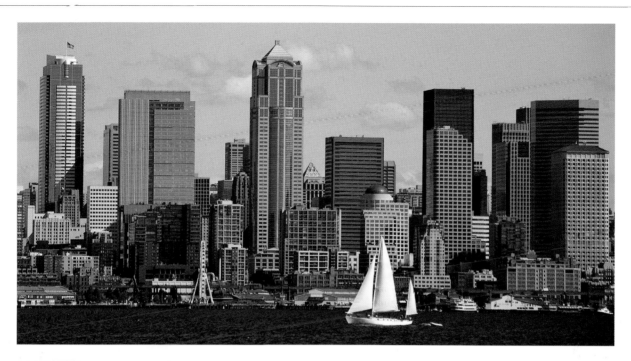

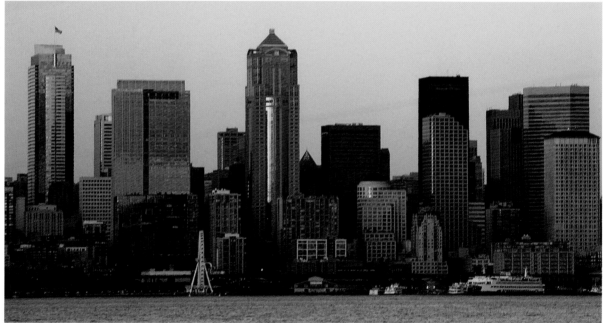

*Seattle skyline at noon (top) and ten minutes after sunset (bottom).*

# On White

+/- (Exp.)  MENU ★ ☾

-2..1..0..1..2+

- tripod
- flash off
- PAS: Set to a close-up mode and use exposure compensation.
- DSLR: Use manual exposure and overexpose by one to two stops.
- smartphone: If your phone has brightness control, crank it up to get a nice white.

*"I think all art is about control— the encounter between control and the uncontrollable."*
—Richard Avedon

Sometimes you want a photograph of something by itself with no distractions. In this exercise, we will work through some of the difficulties of a seemingly simple shot.

*To get a pure white background in this shot, we overexposed by almost a full f-stop.*

# Let's Go!

*white paper reflector*

1. Set up a tripod near a window with no direct sun.

2. For your background, use bright white paper or a pure white tabletop. A white bed sheet will work, but most fabrics tend to cast a color and have too much texture.

3. Get as low as you can and look into your subject, not down on it. This will create a more dramatic shot.

4. Use a piece of stiff white paper to bounce light onto the dark side of your subject.

5. Do a series of exposures (brackets) using your exposure compensation feature starting at zero and going up to +2. Once you have the images downloaded, pick the exposure that gives you the best white.

## Exposure Compensation: Making White Really White

The white background might make the camera think the scene is brighter than it really is and, ironically, make your overall shot too dark. Use exposure compensation or manual to overexpose the image.

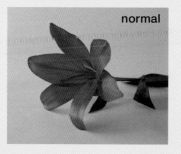
normal

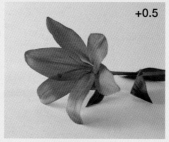
+0.5

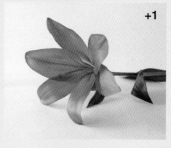
+1

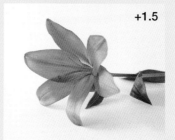
+1.5

+2

*These bracket examples start with the camera's normal exposure and go up two stops.*

# Reflection

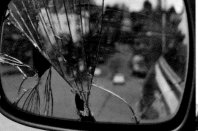

A reflection is a ready-made photograph—a little world within a two-dimensional frame. Looking for reflections is similar to an egg hunt; they are all around us, but we don't typically notice them.

- flash off
- PAS: Use a close up or still life mode.
- DSLR: Use an aperture priority mode and select a medium aperture so you have some depth of field to work with.
- smartphone: This is great because the camera and lens are so small you can get very close.

*"Did you ever wonder if the person in the puddle is real, and you're just a reflection of him?"*
—Bill Watterson

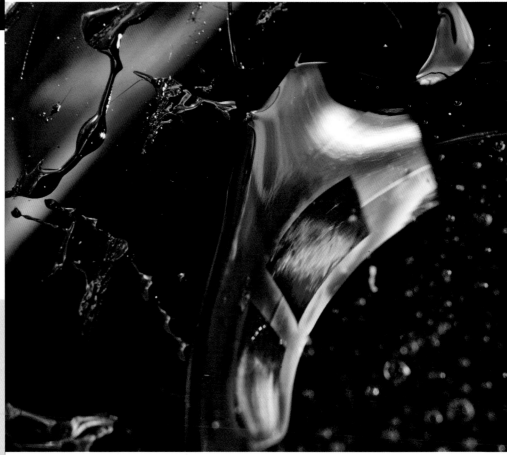

*This shot is underexposed, making the background almost black.*

# Let's Go!

1. Look for shiny surfaces: chrome, puddles, coffee, or eyes.
2. Now look closer and see what is being reflected.
3. Photograph the little world in the reflection.
4. Use exposure control and depth of field to isolate the scene as much as you can.
5. A telephoto lens usually works best.
6. See what else you can add to the scene by bringing something or someone into the reflection.
7. Create your own scene with drops of water, honey, oil, or paint.

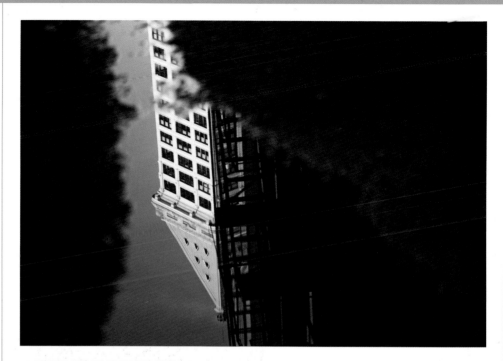

**Above:** *Notice in this puddle shot how the building is in focus, but the puddle and the ground is not.*

**Left:** *Shiny, curved metal surfaces are a fun-house of possibilities.*

## Mixed-Media Project with Carla:
# Cereal Box Photo Paintings

In this assignment, you will transfer a photographic image onto a gesso-textured piece of recycled cardboard (a cereal box). We will use t-shirt transfer paper and one of your shadow photos from Lab 9.

- photo of shadows
- recycled cereal box or similar
- brayer
- white gesso
- ink-jet transfer paper for light fabrics, cold peel
- inkjet printer
- iron; heat gun
- sheet of parchment and matte board to protect iron and tabletop
- optional: watercolors, and brush

*"Fall in love with the back of your cereal box."*

—Jerry Seinfeld

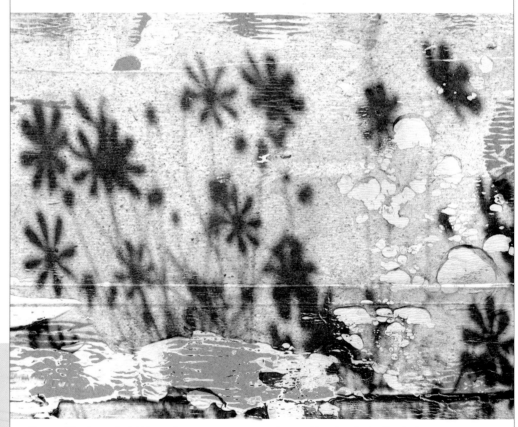

*Flower Shadows, t-shirt transfer paper, gesso, and cereal box by Carla Sonheim.*

# Let's Go!

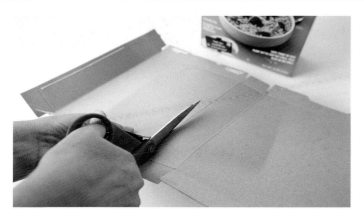

Fig. 1: Trim the cardboard box.

Fig. 3. Adjust the image contrast.

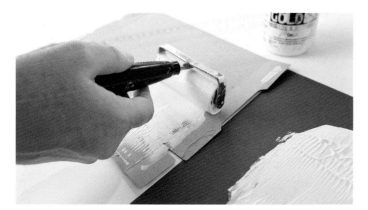

Fig. 2: Apply gesso to the cardboard.

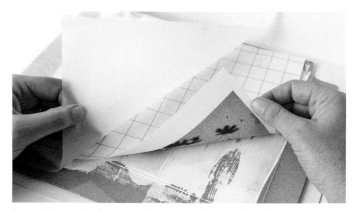

Fig. 4: Layer the image and paper on the cardboard.

1. Flatten out a cereal box and cut a rectangle that measures approximately 10 × 13 inches (25 × 33 cm) (fig. 1).

2. Apply a thick layer of gesso onto your brayer and roll the gesso lightly onto the unprinted side of the cereal box (fig. 2). Use light pressure so some of the cereal box shows through; set aside to dry.

3. Size your shadow photo in your editing program to fit on your gessoed cardboard. Increase the contrast if necessary to give your image a solid white and black (fig. 3). The image will transfer backwards; you can reverse it before printing in your editing program if desired. Print your image according to the transfer-paper instructions.

4. Preheat your iron to the highest cotton setting. You will need to iron on a hard surface such as a table protected by matte board, not on an ironing board. Place the transfer paper, image side down over the painted cardboard, and then cover with a sheet of parchment to protect your iron (fig. 4).

# Let's Go! (continued)

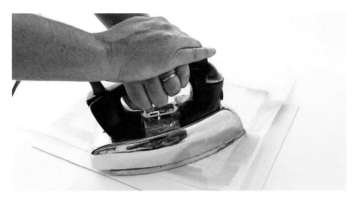

**Fig. 5:** *Iron with lots of pressure.*

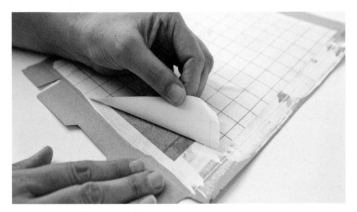

**Fig. 6:** *Peel off the transfer paper.*

5. Open a window for ventilation and iron according to the package instructions. Apply firm, double-handed pressure and move the iron continuously in a slow circular motion (fig. 5); let cool completely.

6. Carefully lift a corner of the paper backing to make sure the plastic transfer is completely adhered to the surface (fig. 6). If it doesn't peel back easily, repeat step 5.

7. Peel off the transfer paper. You will likely have several areas that didn't adhere properly; this is common and will add interest and

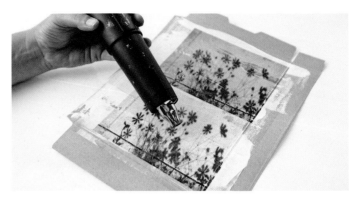

**Fig. 7:** *Melt areas with a heat gun.*

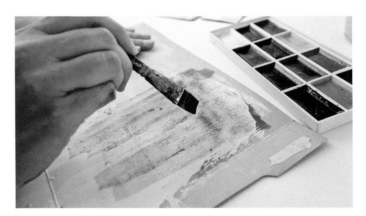

**Fig. 8:** *Add watercolor if desired.*

texture to the piece. Carefully aim a heat gun at these areas to melt it into the surface (fig. 7). (If you get too close with the heat gun, circular bubbles will form. I like the added texture, but if you don't want this effect, go gently with the heat gun.)

8. Experiment! You can achieve even more texture and color by using the printed surface of the cereal box at the gesso stage (step 2) or by painting a light tint of watercolor over the gesso before applying your transfer (between steps 2 and 3) (fig. 8). When you have a variety of textured-photo paintings on hand, you can develop them even more with paint.

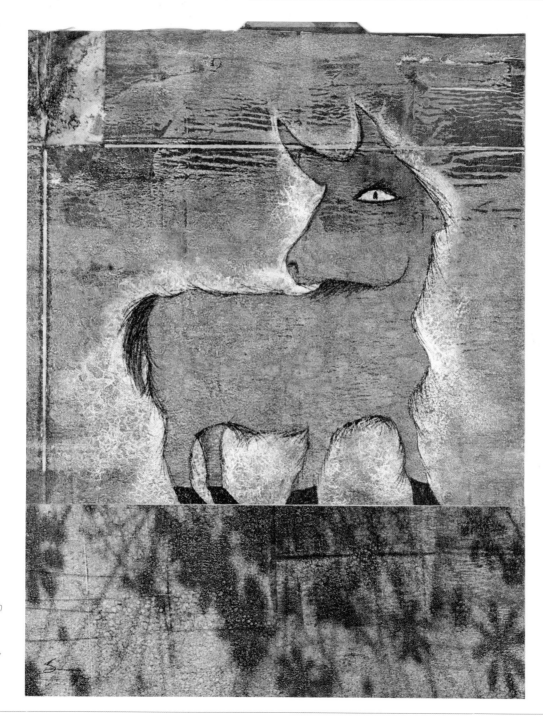

*This little pony was outlined with a black ballpoint pen and some gesso was lightly applied around the edges.*

# Fellow Travelers

**UNIT 3**

**IN PEOPLE PHOTOGRAPHY,** the interaction between the subject and the creator has a huge effect on the end result. Even though you are photographing someone else, the images have more of you in them than other types of photography because your personality is affecting your subject. What you do or say won't affect a landscape but it will affect your model. Most of what the model is thinking and feeling is related to the photographer moment by moment, and the camera is capturing it all.

The goal of this chapter is to put you in situations where you will develop a relationship with your subject. And it may not be quite the relationship you expected.

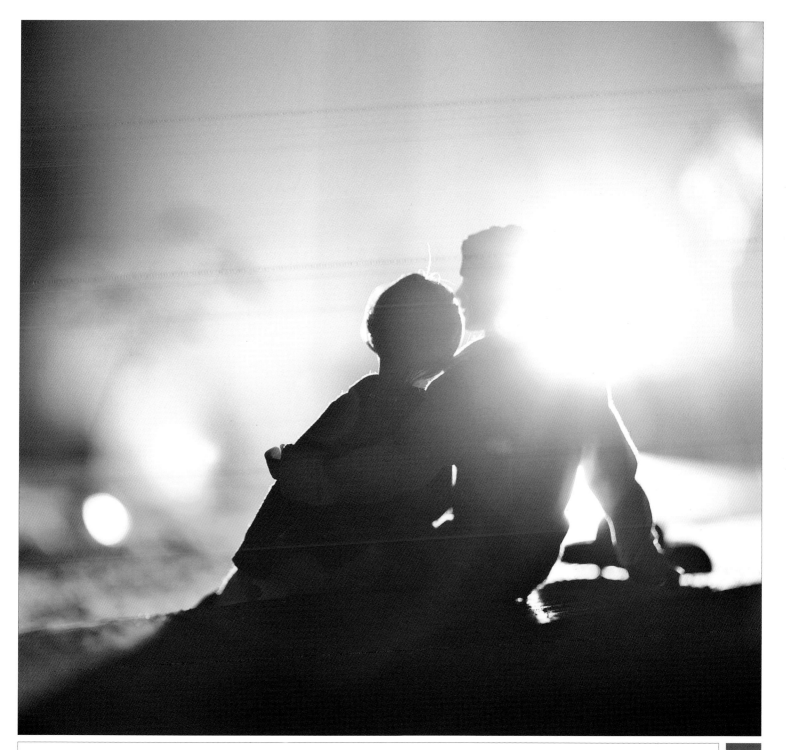

# Cat and Mouse

- flash off
- PAS: Choose a portrait mode. This would be a good time to try an artistic mode such as black and white or vintage.
- DSLR: Use an auto mode and auto focus.
- smartphone: Just point and shoot. Try to anticipate your subject's movements so you don't miss anything.

One of my favorite photographers is Elliot Erwitt who had a talent for capturing moments of quirky humanity on the street. In this lab, we've invented a silly game to create a situation that will hopefully lead to some unique and spontaneous shots.

*If you have a mode for sports or moving subjects, use it; you will be too busy chasing your subject to think about exposure.*

*"To me, photography is an art of observation. It's about finding something interesting in an ordinary place."*

—Elliott Erwitt

## Let's Go!

1. Scout out a location where you have lots of room but also have some natural features such as furniture, trees, and rocks.
2. Stand back-to-back with your model.
3. Take three paces apart, similar to a duel.
4. The model then takes one step in any direction and freezes.
5. The photographer takes two steps in any direction and then takes several shots.
6. Repeat steps 4 and 5 until your model screams or you run out of card space.
7. Make up new rules to increase the silliness.

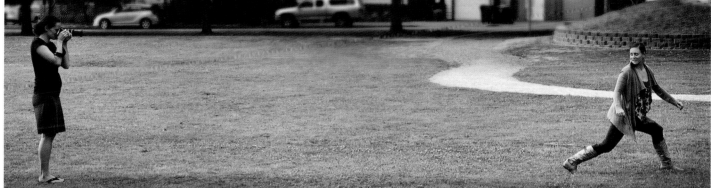

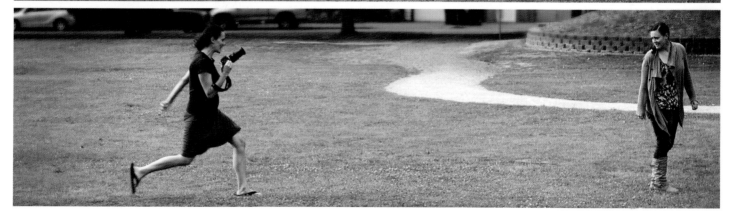

*Photographer and model (sisters) become predator and prey.*

# Make Believe

Settings

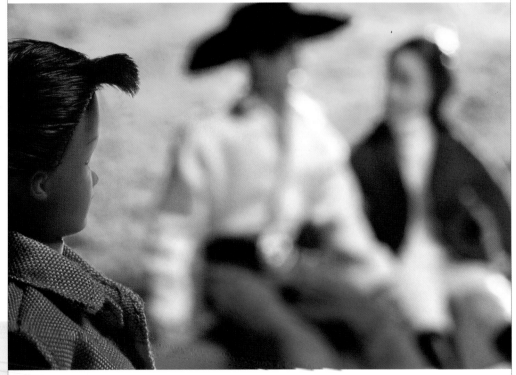

Studio photography is like fiction writing; you have complete freedom. You create the environment, colors, position, and so on. You can translate the real world onto your set using symbols. This is visual storytelling and for this lab you have total control over your models.

- tripod recommended
- flash off
- PAS: Use a macro or still life mode. Move back from your set and zoom the lens to frame your scene.
- DSLR: Use auto or manual exposure. Use manual focus so you have total control. Pick an aperture that gives you an appropriate depth of field.
- smartphone: Zoom in if you can. A wide-angle view makes it difficult to control the background.

*"Barbie is just a doll."*

—Mary Schmich

*Dream up a narrative like this love triangle.*

# Let's Go!

1. Use dolls, stuffed animals, or other small representations of humans or animals to create a small scene.

2. Tell a story with setting, main characters, supporting characters (maybe a villain), and a plot.

3. Write out a back-story for your characters to get into feeling the parts. This will also give you ideas for props, lighting, and more.

4. Consider all the visual information: color, camera angle, and background.

5. Use focus and depth of field to concentrate on the most important action.

6. Keep the background as far from the subject as possible so it doesn't compete with the subject. This also adds depth and reality to the shot.

7. Use light to enhance the mood. Use clamp lights, flashlights, and bounce light off surrounding surfaces for soft shadows.

Close the Door! *by Grace Weston.*

# LAB 22 Faceless

**Portrait**

In order to make more personal photographs, we need to wipe away our preconceptions about what makes a good image. For example, we often tell people to smile when we take their picture or at least look at the camera. In this exercise, we can experiment with the idea of identity by creating a portrait of someone without showing their face or head.

- flash off
- PAS: Use a portrait mode.
- DSLR: Use an auto mode or portrait setting. Once you begin shooting, you don't want to worry about exposure.
- smartphone: Just fire away!

*"I do not paint a portrait to look like the subject, rather does the person grow to look like his portrait."*
—Salvador Dali

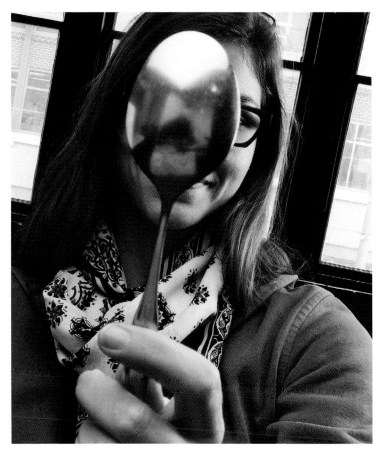

Faith and Spoon

# Let's Go!

1. Select a model. This is one assignment where it helps if they are shy!
2. Find a location with lots of light and a simple background.
3. Decide how you want to obscure the face. This can be related to the person you are photographing or just something fun.
4. Take some test shots to make sure you are happy with the exposure and background.
5. Shoot from a variety of camera angles: stand back and zoom in, get close with a wide angle, or have them lay face up on the floor.

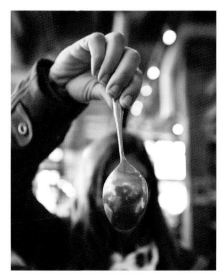

*Don't settle for the first take. Work the shot and try different variations.*

Erik and Oly

# Window Light

Portraits by a window can be very beautiful. The strong direction of light creates mood and drama while the soft shadows bring out the richness of the skin.

- flash off
- PAS: Use a portrait mode.
- DSLR: Use a wide f-stop (low number) such as f/4. This will limit depth of field and blur the background.
- smartphone: Use your phone's zoom feature and step back several feet from your model. This will avoid the distortion caused by being too close to the subject.

*"A portrait! What could be more simple and more complex, more obvious and more profound."*
—Charles Baudelaire

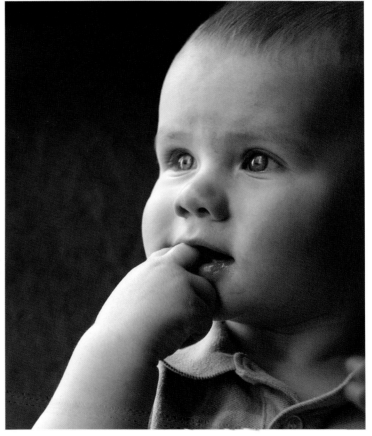

*This portrait of Liam was shot at f/4 to limit the depth of field, giving un a soft blur in the background.*

# Let's Go!

1. Position your subject close to a window with no direct sunlight.

2. Place your camera as close to the wall or window as possible, so the window is not in the frame.

3. You should be 5 to 7 feet (1.5 to 2 m) from your subject. Zoom the lens in to frame your subject; a medium telephoto works best. Anything wider than a normal lens will distort the face and make it unflattering.

4. Turn off all lights in the room; your background should go dark.

5. Use a white card or hang up a white sheet opposite the window to add "fill" light.

6. Take lots of shots and move around with the camera. Both you and your model will become more relaxed as you continue shooting.

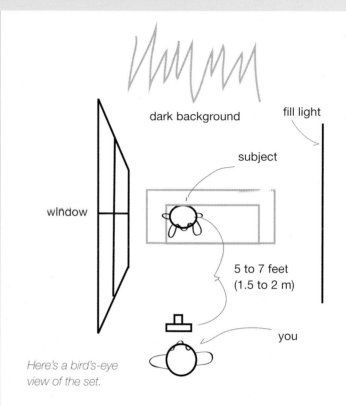

*Here's a bird's-eye view of the set.*

## Add Drama; Darken

With a dark background, the camera will tend to overexpose your subject. Use exposure compensation or manual to darken and create a more dramatic shot.

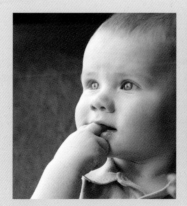

*Normal Exposure*

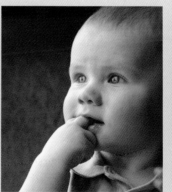

*Exposure compensation −.5 stop*

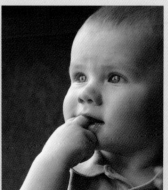

*Exposure compensation −1 stop*

# LAB 24 Animal Parts

Sports

- PAS: Use a sports or action mode. Zoom in close.
- DSLR: Pick an auto mode for action. Use a telephoto lens or zoom. A flash might be helpful, but only if you don't get too close to the subject where it tends to ruin any natural light.
- smartphone: Practice holding and firing the camera at various angles so you can shoot with the camera away from your face.

> *"A man who carries a cat by the tail learns something he can learn in no other way."*
> —Mark Twain

There is an ancient folktale that tells of six blind men and an elephant. Each man felt a different part of the elephant to determine what the animal was like. One man felt the tail and said an elephant was like a rope. Another man felt a leg and said an elephant was like a tree. Create your own versions of what animals are like by photographing only parts of them.

*Right: Don't rush your shots. The longer you hang around animals, the better images you'll likely get.*

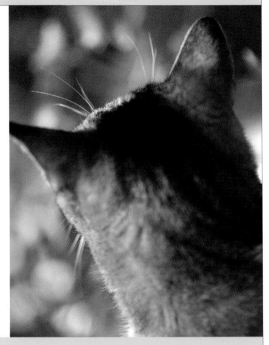

## Let's Go!

1. Take close-ups of as many different animals as possible, concentrating on only one part of their bodies: feet, tails, ears, and so on.
2. If you can't get close enough with your zoom, crop into your images later to isolate a single part.
3. You may have to wait and watch until the animal moves into the right light.
4. Fur absorbs lots of light, so hard sunlight is better than shade. You may also need to overexpose using exposure compensation if your subject is dark.
5. Think about composition and vary your camera angle to make a dramatic shot. Get low or high; shoot from an angle that we don't normally see from.
6. Position yourself so you have a plain background.

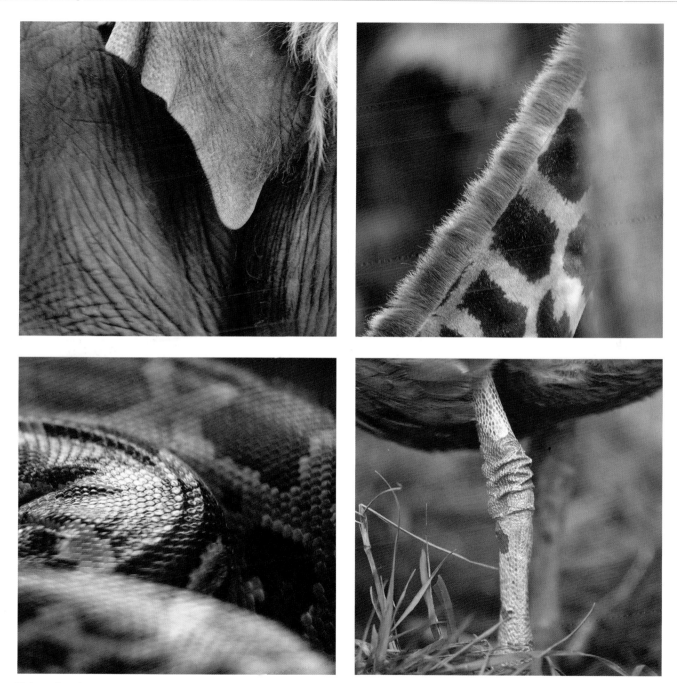

*This project is a great excuse to visit a farm or zoo.*

# Tension

In photography, tension is the sense of something that just happened or is about to happen. In graphics or design, tension describes the push and pull of lines and shapes within the frame. Both of these aspects help us to tell a story, giving a sense of life and motion in a still image. Use both composition and timing to create some portraits with tension.

- flash off
- PAS: Use a portrait mode.
- DSLR: Use an aperture priority or manual mode and set your lens to a large f-stop (low number) for shallow depth of field.
- smartphone: Timing is critical, so hold the camera very still and practice taking a few shots to get a feeling of exactly when the camera will fire so you can capture your moment.

*"The only reason for time is so that everything doesn't happen at once."*
—Albert Einstein

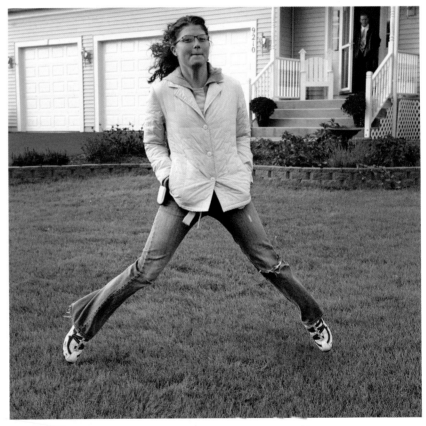

*Having your subject jump is always a good way to loosen things up.*

# Let's Go!

1. Find a willing model or two.

2. Make sure you have lots of room on your memory card.

3. Set your model(s) up in a place where you have good light and a fairly plain background.

4. Take a few shots of the model(s) standing in place.

5. Now create tension: jumping, standing on one foot, or pushing each other are the obvious starters.

6. Be creative and direct the action. Let thoughts just come to mind; try anything. Most models will get into it and start clowning around, so shoot like crazy.

7. Move to a different location and try more variations.

## Taking It Further

Go out into a busy public place and try to capture shots with tension of people moving around. Once you know what you are looking for, you will start to see it everywhere: a foot in mid-step, a hand reaching for a door handle, a swinging jacket on a shoulder, and so on. Use a long telephoto and watch and wait. The timing is critical, so you will have to anticipate the action. The adage is: "If you see it through the viewfinder, you have missed it."

# 26 Bugs

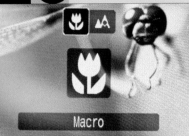

**Macro**

- tripod
- flash off
- PAS: Use a close-up or macro mode.
- DSLR: Auto mode works well. Set lens to a macro or close-up mode.
- smartphone: Make sure you know exactly where the phone lens is located before "going in" so you can get close without blocking it.

*"Study nature, love nature, stay close to nature. It will never fail you."*
—Frank Lloyd Wright

Photographs allow us the chance to study the world at our leisure, spending time with subject matter that we wouldn't approach in real life. For this lab, we are going in close to spend some time with smaller creatures.

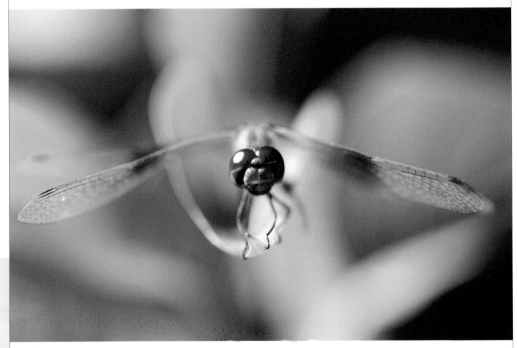

*Get close; be another bug.*

# Let's Go!

1. Find some bugs and photograph them. Use a tripod if possible.

2. Focus manually if you can and bracket focus as you would for other exposures. Focus is very critical when up close to your subject, and auto focus will often miss the point you want.

3. Pay close attention to the background. Try to position yourself so the background falls into shadow.

4. Work the shot. Getting any shot of insects or wildlife is an accomplishment, but don't be too confident. Keep shooting; I often will get only a few frames out of hundreds that have the exact right focus and light.

5. Be patient. Some insects, such as butterflies, will get used to your presence and give you some great opportunities.

6. Find good light. A dark, shadowy place may have great bugs, but they won't show up without good illumination.

7. Flash? A special setup such as a ring light is great for close-ups, but the regular built-in flash will ruin any natural feeling to your shot.

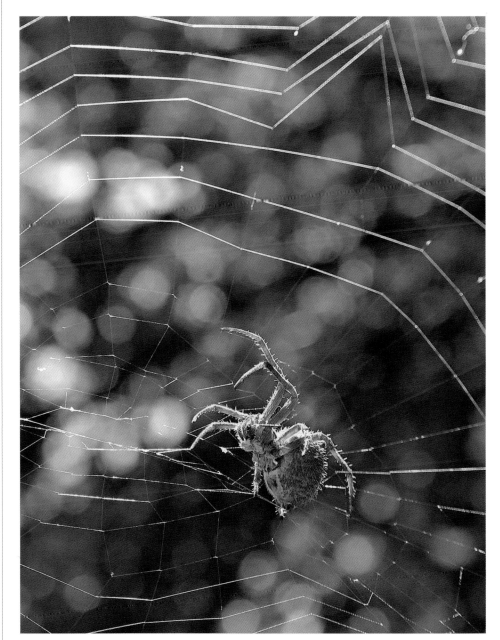

*Backlighting is essential for capturing webs.*

# Stranger Danger

Settings

**HELLO**
my name is

Photographing people, especially strangers, can be overwhelming depending on your personality. Sticking a camera in someone's face is not for the shy. To help get over that block, go out with your camera and ask a total stranger to take your picture instead; be a tourist.

- flash off
- PAS: Use a portrait setting.
- DSLR: Use an aperture priority mode and choose a medium aperture about halfway between the minimum and maximum aperture setting.
- smartphone: Show your photographer how to use your particular phone.

*Christi gets her picture taken by a stranger.*

"People assume you can't be shy and be on television. They're wrong."
—Diane Sawyer

# Let's Go!

1. Find a good background and light in a public place and ask a total stranger to take your picture wtih your camera.

2. Spend some time in the area before approaching someone. Bring a friend with you to watch from the sidelines for security.

3. Set your exposure beforehand to make it easier on your photographer.

4. Look for other people taking photographs. Offer to take a group shot with their camera before asking them to do the same for you.

5. Taking it further: Repeat the process in different locations to create a photo-essay of your travels.

6. This is a great assignment to do on vacation. The more you do it, the more comfortable you will become with asking.

*These two shots from Wes's "100-Shots" assignment show a self-portrait and a shot taken by a stranger.*

## Is This a Self-Portrait?

If you set up a shot of yourself and hand the camera to someone else to click the shutter, aren't you really making a self-portrait? It's your idea and you control all the variables, so it's a self-created image of you; right?

I would argue that it's not. When you introduce another person into the process, the intimacy of a self-portrait goes away. Clicking the shutter is always a magical moment, and whoever pushes the button is making a decision (even a small one), which ultimately affects the outcome.

## Settings

- flash off
- PAS: Select a portrait mode.
- DSLR: Use a mode that allows you to control aperture. This will give you shallow depth of field and allow shooting at a faster shutter speed, which must be 1/125 or above to avoid motion blur.
- smartphone: Since you don't have very much control, just make this a fun, candid assignment.

*"My real hair color is kind of a dark blond. Now I just have mood hair."*

—Julia Roberts

When we think of portraiture, we usually think about capturing a likeness of the subject to show personality and identity. In this lab, however, the objective is to capture a feeling. Your job is to work with your subject to create an image that evokes a strong emotion.

Use strong suggestions to elicit emotion. Act like a movie director. Tell them a story or joke. Ask them to think about people they love or a difficult experience.

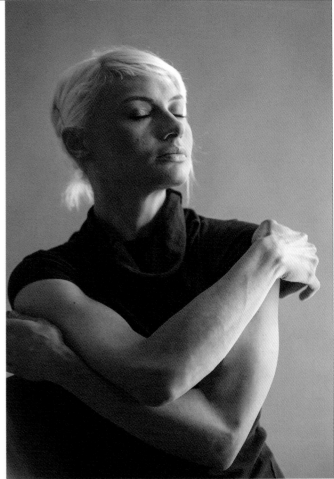

*Here we used strong side light from a window and posed the model to show tension and introspection.*

# Let's Go!

1. Make a photograph that communicates strong emotion using a combination of expression, posing, and lighting.

2. Pick a model you are comfortable with and decide beforehand what you want to express—it can be joy, humor, sadness, or even horror.

3. Set up somewhere where you have lighting that reinforces the feeling you are after. Options include bright sunlight for happiness or soft window light or an overcast day for a more thoughtful feeling. Hard, direct light from a bare light bulb will create hard shadows for a stronger feeling such as anger or frustration.

4. The light direction also plays a part. Placing the light to the side or behind the subject increases drama, while light from the front conveys openness and a happier mood.

5. Pose your model to convey feeling. Turn their body away from the camera or to the side to create tension. Use their arms and hands. Experiment with the camera angle; what does it suggest when you look down or up at the subject?

6. Most important; shoot fast and shoot a lot.

7. Don't stop even if you feel you have the shot. As you shoot more, both you and the subject become more comfortable with the camera.

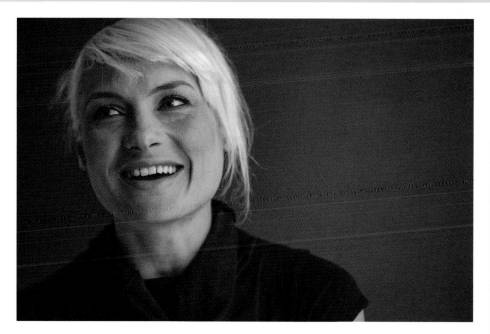

## Tip

Simple utility lights are inexpensive and work great for directing light. You can use them directly on your subject or bounce them off a ceiling or wall for softer light. Set your camera to tungsten white balance if your shots turn out too yellowish with these lights.

## Mixed-Media Project with Carla:

# Put a Fairy on It!

- photograph printed on matte or watercolor paper
- white gesso
- ¼" (6 mm) flat brush (or similar), small detail brush
- flesh-colored water-soluble crayon
- hair-colored water-soluble crayon
- red soft pastel
- mechanical pencil
- vine charcoal
- 0.01 black pen (such as a Micron pen)
- spray fixative
- optional: small set of pastels

*"Let the little fairy in you fly!"*

—Rufus Wainwright

Whenever I have a photograph that needs a little extra something, I just put a fairy on it!

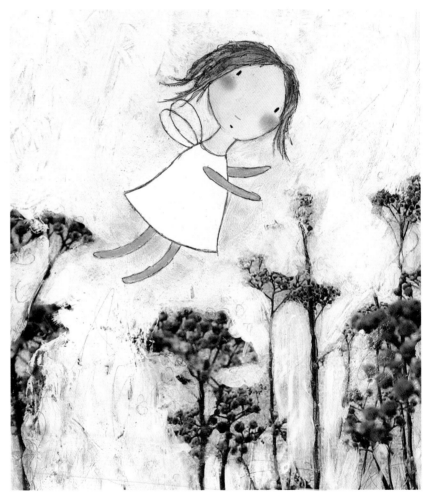

Fairy with Weeds; *mixed media on paper by Carla Sonheim.*

# Let's Go!

**Fig. 1:** *Crop the image and add some background color.*

**Fig. 2:** *Highlight areas with gesso.*

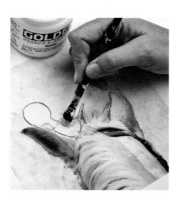

**Fig. 3:** *Draw your fairy.*

1. Find a photograph that lends itself to adding a fairy or two. Here, I used a photo from the "Animal Parts" assignment (Lab 24). Print your image about 8 × 10 inches (20 × 25 cm) on matte or watercolor paper. In this case, I wanted more room to add a fairy, so I cropped the photo and added color to the background before printing. I wasn't worried too much about the background at this point; I just wanted to add some color that I could partially cover up in the next step (fig. 1).

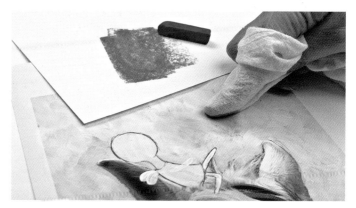

**Fig. 4:** *Add color to background.*

2. Using a dry paintbrush, paint a choppy layer of white gesso around the areas of the photo you want to retain. Vary your brushstroke lengths and directions. Some of the dark background will show through a little and provide a nice texture (fig. 2).

3. Lightly draw in your fairy shape with a pencil and then fill it in with a smooth layer of gesso (fig. 3). Use a smaller brush to paint in the arms, legs, and fairy wings; let dry completely.

4. Optional: To add a tint of color to your background, scribble a patch of pastel on a piece of scratch paper. Using a rag, lift up the pigment and rub it in a circular motion over the gessoed background (fig. 4).

## What Does "Dry Brush" Mean?

A dry brush is exactly what it sounds like; it's a brush that hasn't been dipped in water. Just dip it into the thick gesso and begin painting. This allows for a rougher, more textured paint stroke.

If your brush was already wet, squeeze off as much excess water as possible before you begin painting.

*Fig. 5:* Color in the face, arms, and legs.

*Fig. 6:* Add cheeks with red pastel.

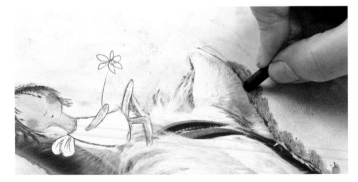

*Fig. 7:* Darken the edges with charcoal.

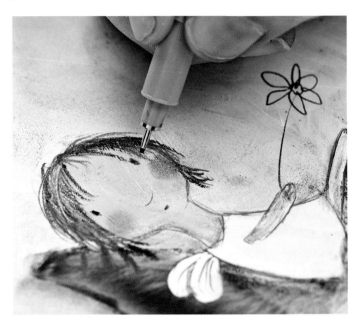

*Fig. 8:* Darken the eyes and mouth.

5. Use a skin-colored water-soluble crayon to color in the face, arms, and legs (fig. 5). Smooth out the color by rubbing it with a rag.

6. Use your pinky finger to add cheeks with some red pastel (fig. 6). Add hair with another crayon and then outline your fairy using a mechanical pencil. Add eyes, a nose, and a mouth.

7. Now take some vine charcoal and draw around the edges of your subject; spread out the charcoal with your finger (fig. 7).

8. As a final step, darken the eyes and mouth just a bit with a small black pen (fig. 8). Spray the picture with fixative.

*Opposite:* Fairy with Angel; *mixed media on paper,* by Carla Sonheim.

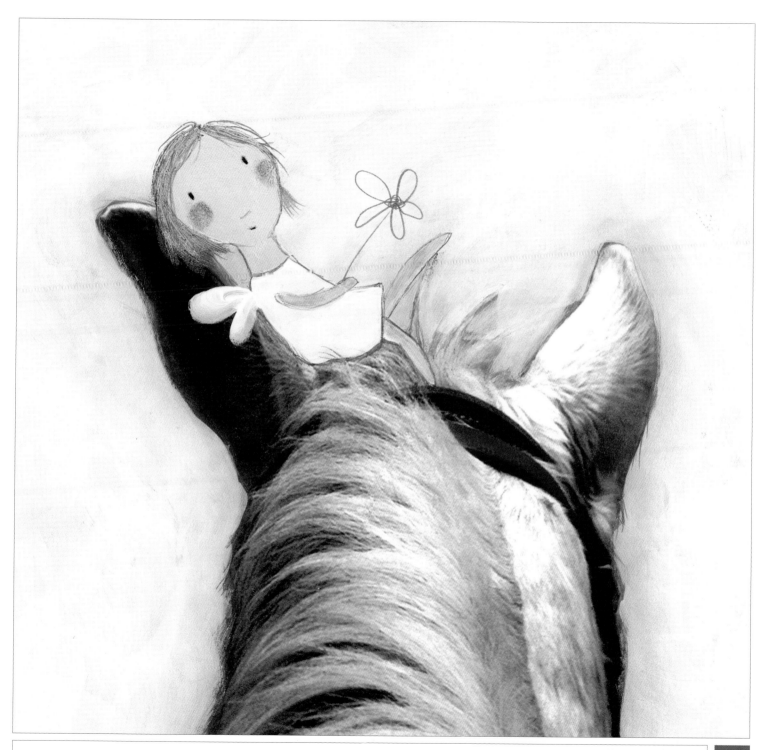

# Talking to Yourself

**WHO IS THE AUDIENCE** for your photography? Most of us like to share our images, and in sharing images, we share experiences and hopefully our thoughts and feelings. By deciding what you want to make images of, you are telling the world something about yourself. In this chapter, we turn the tables and look at what you are telling yourself about the images you make.

For these exercises, think of yourself as the audience. It may be helpful to actually decide that you won't show anyone what you shoot. This can be very powerful because it forces you to think about what photography means to you. With no praise or critique from the outside, it becomes similar to a diary or personal journal.

# Camera-to-Work Day

- flash off
- PAS: Set to a mode that fits your scene.
- DSLR: Use a mode that gives you some control over shutter speed and aperture.
- smartphone: This may be the perfect tool for this assignment. Set an alarm to remind you when to shoot.

For this lab, you will create a personal photo journal of your work or daily environment. With a collection of images, tell the story of an eight-hour period during a normal day. Look for details that hint at what you are doing and where you are.

*Pack your camera with your lunch!*

*"Time is but the stream I go a-fishing in."*

—Henry David Thoreau

# Let's Go!

1. Take your camera with you on your travels today and take a shot every thirty minutes for eight hours.

2. The subject of each shot should be the thing that elicits the strongest emotion for you at that moment. Think of this as a visual diary of your feelings.

3. Dig into to your photo toolbox for techniques to tell the story: get close to objects, use shallow depth of field to blur distracting backgrounds, or use motion blur with a slow shutter speed to show movement.

4. Edit your images down to a selection that best conveys your day and arrange them into a collage.

- flash off
- PAS: Use a snapshot mode.
- DSLR: Use a full auto mode you are accustomed to using so you don't have to think about settings.
- smartphone: Take lots of shots and try not to look at them until you get home.

*"I am free of all prejudices. I hate everyone equally."*
—W.C. Fields

I think the ultimate goal in photography is to create images that reflect your personality and feelings; otherwise, we are just recreating what has already been done. So what do you feel strongly about?

# Let's Go!

1. Find a quiet space and try to visualize something you hate.

2. Your objective is to make at least four images that represent your loathing.

3. Think outside the box. You may feel like you don't have physical access to some of the things you are thinking about. How do these things reach you—sound, television, smells, or something else? Then think about the visual cues you do have.

4. Take time to explore the subjects and let your gut direct how you approach them.

5. It is important to not be literal or illustrative for this assignment. In other words, don't think, "I hate this so I am going to make it dark." And don't try to express your feelings using photo techniques. Just shoot it and keep shooting while thinking about how you feel.

6. Let your feelings flow though your hands and camera—this sounds goofy for photography, but you may not realize how many decisions we make unconsciously every time we click the shutter.

7. Download your shots but don't look at them for at least twenty-four hours. Then study each one; can you see yourself in any of them?

Are you an expert at or passionate about something? This project is about making a step-by-step record of some process that interests you. Photography can be expressive, not just emotionally but also practically. Using photos to demonstrate a task or procedure will help refine your ability to compose images that communicate a single, clear idea.

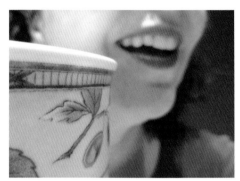

*How to Brew Satisfaction by Cheryl Razmus.*

- tripod
- flash off
- PAS: Use a still-life setting.
- DSLR: Manual is a good choice because you want all the images to match as you go through your process. Select the shutter speed and aperture that gives the best results and then leave it there.
- smartphone: Frame your shots carefully so they match each other.

## Let's Go!

1. Make a series of images that document a process that you are good at or passionate about: cooking, sculpting, repairing, massage, or ...?

2. Lay out your steps beforehand so you can plan your images. Think like a movie director: establishing shot, action shot, close-up, and closing shot. It helps to write each one out.

3. Pick a location with even, soft light that won't change while you are going through the steps.

4. Carefully compose each shot to give just the information necessary; remove anything that doesn't communicate clearly.

5. Document more steps than you think you will need and select the most informative shots in the editing process.

*"Not the fruit of experience, but experience itself, is the end."*

—Walter Pater

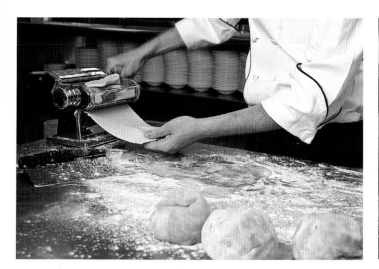
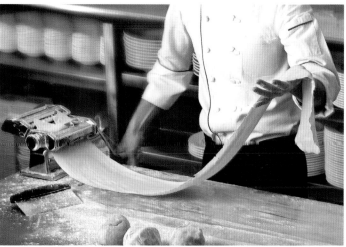

*A process that involves repeated steps, like pasta making, is great for this assignment because you have several opportunities to get the right shots.*

# LAB 33 Self Portrait

**Settings**

- tripod
- flash off
- PAS: Use a portrait mode and locate the self-timer function in the menu.
- DSLR: Use manual focus and exposure. Set up the camera and see what the camera recommends for exposure and use that as your starting point.
- smartphone: You need a self-timer function for this assignment. Prop your phone up with books and do lots of test shots.

I love to give self-portrait assignments to my students, but I hate doing them myself. Getting over the self-conscious hump can be difficult. The process of being both creator and subject, however, is a rich opportunity for self-expression and learning.

Consider black and white as an option as in this telling self-portrait by Anni Christie.

*"I am a deeply superficial person."*

—Andy Warhol

# Let's Go!

1. Stand in front of the mirror and decide how you want to portray yourself. The only rule is that you, or part of you, is in the shot.

2. Find a location that has good light and supports the mood you want to convey.

3. Carefully consider your background. Do you want an environment or something simple?

4. Set up your camera on a tripod or use a tabletop, counter, or stack of books.

5. Find a stand-in for where you will be in the shot. A pillow, mop, or a stuffed animal will work.

6. Take test shots to get the focus and exposure right.

7. Set the timer or remote and jump into position. Try shooting without looking at the screen until you finish several poses.

*The mop as stand-in.*

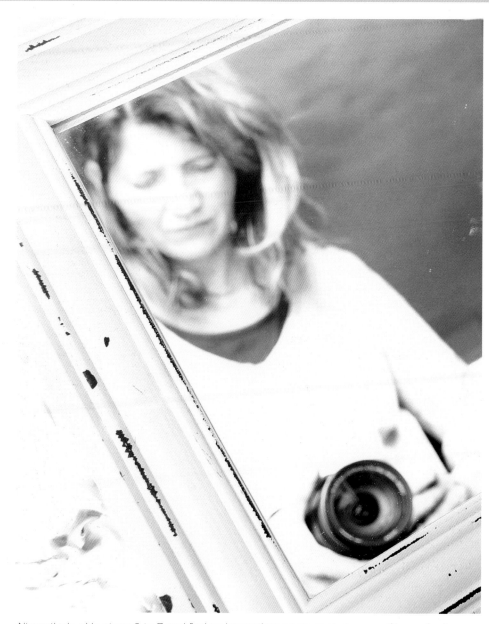

*Alternatively, skip steps 3 to 7 and find an interesting way to capture yourself in a reflection or shadow. Self-Portrait by Valérie Astier.*

# Observation <span>Friday</span>

Time to take a break from making photographs and spend some time enjoying the work that already exists. Go to the library and grab all the photography books you can carry. Try to pick subjects and artists you have never heard of before and flip through the images for an hour.

- Put your camera down for today.

*"The camera is an instrument that teaches people how to see without a camera."*

—Dorothea Lange

*For this assignment, it's important to get your hands on some actual books and get away from the computer screen. The pace of flipping through a book and the reproduction quality of ink on paper can be a much more satisfying way to appreciate the work.*

# Let's Go!

Here is a list of some areas of interest along with a photographer that I think represents it well. Pick a few that grab your attention and look them up, study, and be inspired.

- Modern Still Life: Edward Weston

- People/Contemporary Celebrities: Annie Leibovitz

- Babies: Anne Geddes

- Dogs: William Wegman

- Modern Documentary: Paul Strand

- Contemporary Advertising and Fashion: Hans Neleman

- Modern Abstract: László Moholy-Nagy

- Contemporary Culture/Young Talent: Matt Eich

- International Documentary: Gwenn Dubourthoumieu

- Contemporary Nature: Art Wolfe

- Historical Landscape: William Henry Jackson

- Contemporary Life: Joel Meyerowitz

- Advertising: Hiro (Yasuhiro Wakabayashi)

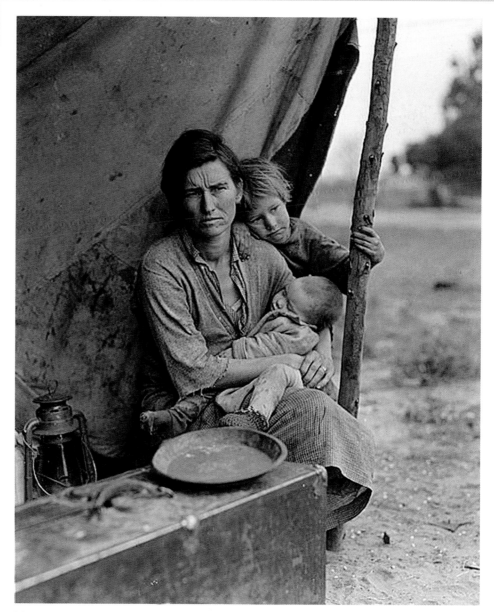

*Here is an interesting outtake from Dorothea Lange's famous photo-essay of migrant workers for the Works Progress Administration during the Depression.*

I have had two separate incidents while traveling in Central America where a native person asked me, "What things do you collect?" I am not sure where they got the idea that Americans collect things, or if it was coincidence or a mistranslation, but it made me think about how our possessions define us. Here we investigate that notion by photographing a random collection of our stuff.

- flash off
- PAS: Use a still-life mode.
- DSLR: This is a good opportunity to practice manual mode because you have full control of your situation.
- smartphone: If your phone has a zoom function, step back from your set up and zoom in about halfway to frame it.

*"A house is just a pile of stuff with a cover on it."*

—George Carlin

*Find a group of things that already exist together as a collection. Here's everything in my junk drawer.*

# Let's Go!

1. Gather up a natural occurring collection of your stuff. This must be something totally random—maybe everything currently on the kitchen counter or everything in your pocket or purse.

2. Set up your shot on a plain surface near a window, without direct sun.

3. Start laying out your stuff; arrange it so it looks natural. This is called controlled chaos; it looks like you just found it that way, but was actually carefully arranged to make visual sense.

4. Set up your camera at a low angle so you are looking across the collection rather than down at it.

5. Take some test shots and study them.

6. Move things around so everything in the shot can be identified but still creates some tension and design.

*Window light is a good soft light source for shooting a group of small objects.*

## Tip

Cut a dime-size hole in a sheet of paper and then move it around on the camera screen to see only a part of the image at a time. Can you identify what is going on in each section, or are there large areas with dark holes or mystery blobs? Move things around until every part of the shot makes visual sense. This can be tedious, but hang in there.

# LAB 36 Document

- flash off
- PAS: A snapshot mode is best. Use black-and-white if you have it.
- DSLR: Use an auto mode that allows you to move fast and shoot in lower light situations. Give up depth of field for stop action.
- smartphone: Shoot multiple shots of each scene and edit out the best shots later.

Is photography fact or fiction? How you approach any subject is affected by your opinion, and therefore the images will have a particular slant. In this lab, imagine you are a reporter and you have been assigned to cover something or someone with an in-depth essay.

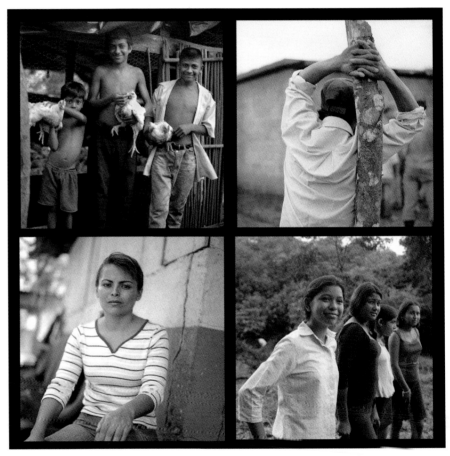

These images are from a project documenting people in rural villages in Nicaragua.

*"Black and white are the colors of photography. To me they symbolize the alternatives of hope and despair to which mankind is forever subjected."*

—Robert Frank

# Let's Go!

1. Choose either an activity or a person to cover. The subject should be something you aren't already too familiar with. The photography and research should go together, and you are the audience.

2. Make arrangements to access your subject. If it's a person, see if you can shadow them for part of a day. If your subject is an activity, find out schedules and see if you need permission. You could follow a vet around for a day or go to a model airplane show.

3. Shoot in black and white or convert the image later.

4. Be sure to have plenty of memory-card space and shoot like crazy.

5. Look for the off-stage moments between the action shots.

6. Shoot even if you aren't sure of exposure or focus.

7. Do a quick edit of your images soon after you are finished shooting. Then come back a day later and reevaluate your selections.

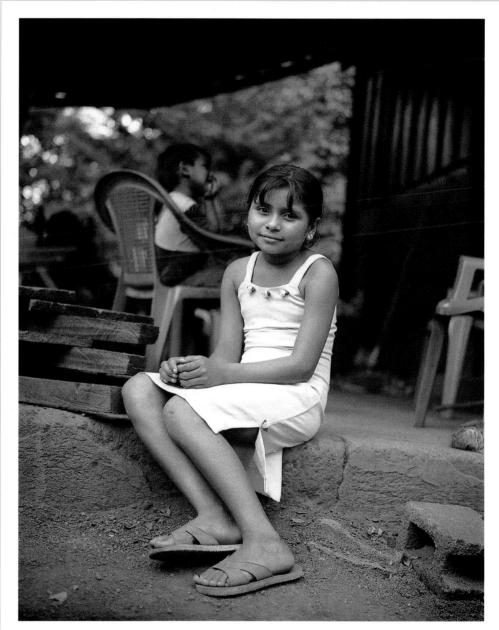

*The more time I spent with the people, the more intimate and fun the images became.*

## Mixed-Media Project with Carla:
# Mini Photo Journal

This multilayered, personal project is a chance to record your experiences and feelings about your images in a handmade journal.

- 10 to 20 photographs
- 3 sheets of double-sided matte inkjet paper, or similar
- inkjet printer
- awl
- needle and linen thread (or similar)
- paper cutter or utility knife and ruler
- pen

*"Habits in writing as in life are only useful if they are broken as soon as they cease to be advantageous."*

—W. Somerset Maugham

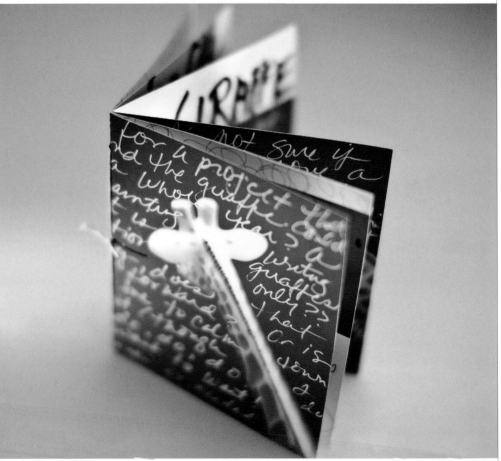

*This project, when viewed later on, should bring you back to the day you took the images and all the feelings associated with them.*

# Let's Go!

Fig. 1: *Keep the images in the center of the page because the pages will be trimmed.*

Fig. 2: *Once trimmed and folded, place the pages inside each other to form a book.*

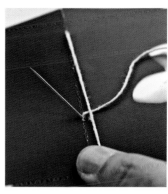

Fig. 3: *During the final step, the needle should come up on the opposite side of the linen thread.*

Fig. 4: *Add words to complete your book.*

1. Gather 10 to 20 photographs to use for this project.

   Open six letter-sized pages in landscape mode using your photo-editing program. Place your photos onto the six pages, leaving areas of white space so you can add words later (fig. 1).

   Once you are satisfied with the layout of your images, print the first three pages onto the matte paper. Now place the three printed pages back into the printer. Print pages 4 to 6 on the reverse side of the three printed sheets. When finished, you will have three sheets of paper with images printed on both sides.

2. Using a paper cutter or utility knife, trim each page to 5 × 10 inches (13 × 25 cm). Fold in half to create three 5 × 5 inch (13 × 13 cm) folded sheets. Place the sheets inside each other to create a book structure (fig. 2). Use an awl to make three evenly spaced holes along the fold through all three layers.

3. For a simple binding, take your needle and push it through the middle hole from the exterior to the interior, leaving about 3 inches (8 cm) of string on the outside. Hold the string end in place while threading the needle out through the top hole. Next, push the needle inside through the bottom hole and then back out through the middle hole (fig. 3). Pull the thread tight and tie the ends together with a square knot; trim if desired.

4. To finish, reflect on the original photo shoot and write whatever comes to your mind—from writing a complete story to just allowing random words and phrases to add texture to your pages (fig. 4).

# Finger Painting

**PHOTOGRAPHY CAN BE MANY DIFFERENT THINGS.** Often it is meticulous, carefully crafted down to the finest detail. Other times it is random, spontaneous, and fast. In the following labs, we will play with some techniques to create unusual images that are fun ways of seeing what your camera can do. Some of the assignments will yield abstract images that have no reference or meaning; they are simply color, line, and form.

The techniques are just a few starting points. Dream up some on your own, swing your camera around, or stick stuff in front of your lens. Digital photography is great because you can see the results immediately. Experimenting is the key; be innovative and silly and think outside the box.

You may find that a particular technique isn't making interesting images, but you may be closer than you think. Hang in there and try different exposures, distances, or motions. Often a process that isn't working will suddenly happen by making the image darker, moving slower, or getting closer—be fearless.

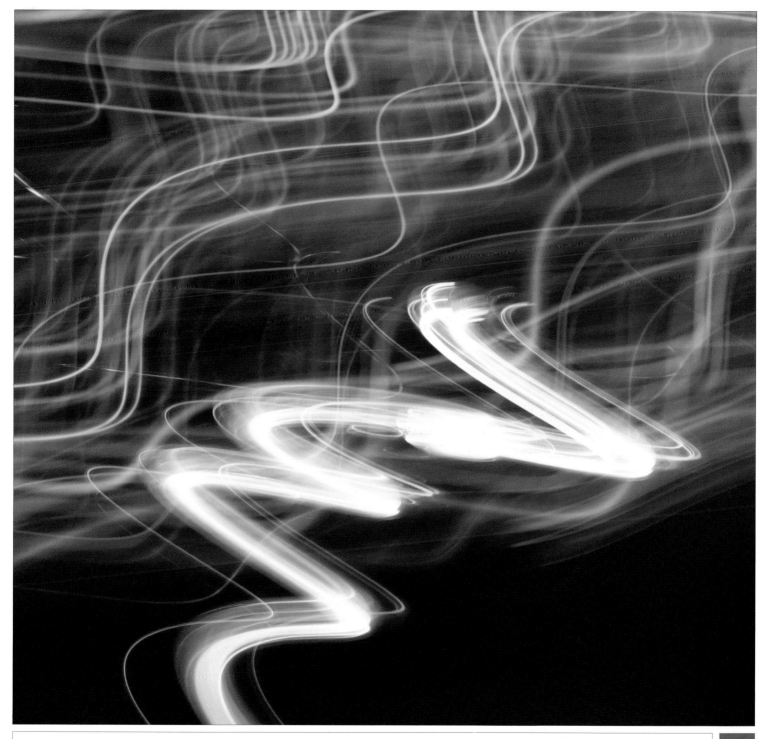

# LAB 38 Blur

- flash off
- PAS: Manually set your ISO to the lowest setting. If you have a manual mode, set your aperture to the highest number.
- DSLR: Manually set your ISO to the lowest setting. Use a shutter priority mode and choose 1/8 second or slower.
- smartphone: Most will automatically use a longer shutter speed in any dark environment.

*"There are no uninteresting things. There are just uninterested people."*
—Jerry Uelsmann

Most of the time we think of blur as bad. However, intentional blur shots are full of surprise and mystery. A motion blur is when something—the camera, the subject, or both—is moving during a long exposure (1/30 second or longer).

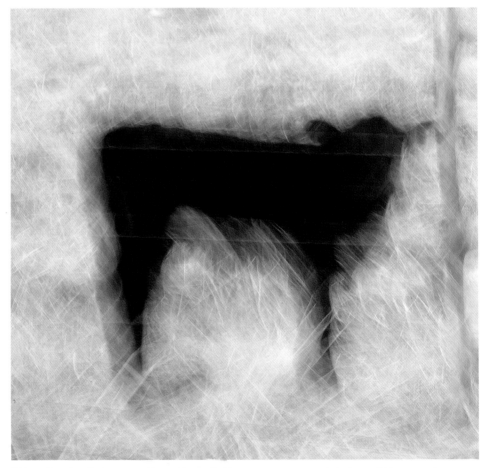

*This painterly-effect was achieved by a slight camera movement during a 1/4-second exposure of a small stationary cow.*

# Let's Go!

1. Your assignment is to create some interesting blur shots.

2. Set the camera to a shutter speed of 1/8 second or slower. The best results are around 1/4 to 1/2 second. This means you need a small aperture (about f/16) and/or a darker environment. Bright sunlight probably won't give you a slow enough shutter speed.

3. Capture movement by using one of the following techniques:

   • Place the camera on a tripod and shoot moving objects: cars, people on the sidewalk, a waterfall, or kids on a swing.

   • Move the camera while the subject or scene is stationary. You can move side to side, up and down, spin it, rotate it, or zoom the lens while the shutter is open.

   • Move the camera while the subject is also moving. Follow the subject to blur the background or move in the opposite direction.

4. The key is to experiment with different shutter speeds and different camera movements. Be careful because you might blur away a whole afternoon!

*In this wonderful shot by Angie Allen, the subject is moving but the camera is still.*

# Squiggle Drawing

**Long Shutter** MENU OFF
◀ **4"** ▶

Create a light painting using by a fixed light source and moving your camera around during a long exposure.

- flash off
- PAS: Use a "night-time" mode. Most cameras will have a "long exposure" setting (see your owner's manual).
- DSLR: Set your camera to manual focus and exposure. Start with an exposure like f/16 at five seconds and experiment from there.
- smartphone: This works if it is really dark and you have bright lights.

*"Light is your crayon, and there's always another color in the box."*

—Tedric A. Garrison

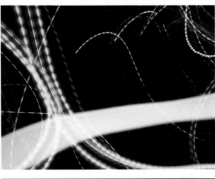

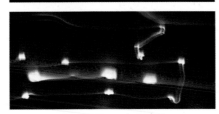

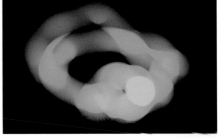

*These squiggle drawings were created with an alarm clock, an iPad, a night-light, a reading light, and vanity lights.*

# Let's Go!

1. Find a light source in an otherwise dark environment; street lights at night work great. Try candles, Christmas lights, toys, or your phone.
2. Point your camera at the light and then start moving the camera and fire the shutter.
3. Take lots of shots, moving at different speeds and distances.
4. Generally a wide-angle lens setting works best.
5. Create effects by zooming the lens, spinning around, or shaking the camera.

## Tips

- Make sure your light source is centered in the frame before you push the button; otherwise, the camera may delay taking the shot while it tries to find something in the darkness to focus on.
- Try using the "B" setting; the shutter will stay open as long as you hold the button.
- Start moving the camera before you hit the button.

*Here is a street scene shot for four seconds using a tripod.*

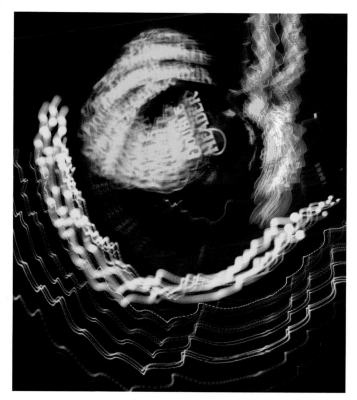

*Here is a squiggle from the same scene shot for two seconds.*

# Head Like a Hole

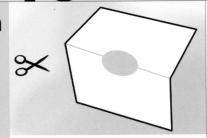

- flash off
- PAS: Landscape mode usually works best.
- DSLR: Use manual mode and set your exposure based on the reading you get before holding up your window.
- smartphone: Photographing people this way can be a hilarious exercise. You may have to practice shooting one-handed with your phone before you start chasing people around.

*"You gotta be able to change worlds."*

—Courtney Love

Photography is like cooking; the final result is the interaction of all the ingredients. So what do you put into your shots? In this lab, we will use a small round window to isolate a few simple ingredients and create our own little world.

*"This exercise made me zoom in on little things, find a new perspective," wrote online student Kerstin Kumpe.*

# Let's Go!

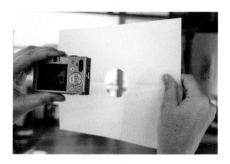

1. Cut a round hole about the size of a ping-pong ball in an 8 × 10 inch (20 × 25 cm) piece of stiff paper or cardboard. Use any color paper you want; effects will vary.

2. Go out into the world and practice framing shots with your round window. When you see something you like, take a shot through the hole—simple as that.

3. Vary the distance from the paper to the camera for different framing and effects.

4. Keep some of the paper in every shot.

*Valérie Astier used a translucent paper for this beautiful shot.*

## Tips

- Two challenges will be focus and exposure because the camera will incorporate the paper into its calculations. You want only what is in the hole to be focused and metered.

- To get focus right, make sure the focus point (little flashing square) is on the subject and not on the paper. If you have face-detection or multiple-point focus, turn it off.

- Correct exposure will depend on whether your paper is lighter or darker than the scene. It might require overexposing by a stop for white paper or underexposing a stop for black paper. Use exposure compensation.

# Night Vision

The light-absorbing ability of digital cameras can produce some amazing images. Leaving the shutter open can record streaks of light and even make a dark night scene look like daytime. The longer the exposure, the brighter the image gets.

- use a tripod.
- flash off
- PAS: Use a long exposure. This is usually in the menu under "night-time" or "long exposure."
- DSLR: Use a manual exposure of f/8 and a shutter speed of one second and experiment from there.
- smartphone: This will work for some night scenes if they are bright.

*"A day without sunshine is like, you know, night."*
—Steve Martin

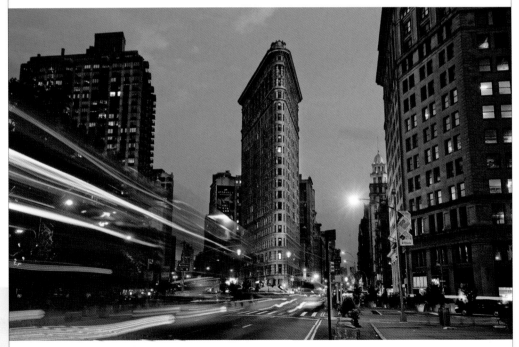

*Iconic landmarks like the Flatiron Building make good subject matter for nighttime shots.*

# Let's Go!

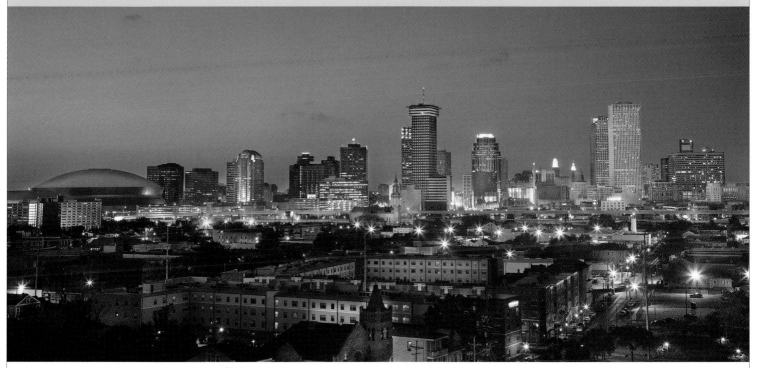

*This twilight shot of New Orleans, Louisiana, was taken about thirty minutes after sunset, when the light in the sky matched the brightness of the city lights.*

1. Scout some nighttime locations with interesting features and lighting, such as a bridge or building.
2. Set up your tripod and do some test shots to establish your composition and framing.
3. Start shooting about twenty minutes after sunset using a range of shutter speeds. Take a series of shots every ten minutes or so until the sky is completely dark. This will give you a series of images with varying degrees of brightness in the sky.
4. Sometime after sunset, there is a point called "the magic minute" when the light from the sky matches the brightness of the window lights. If you wait too long, you may end up with a black sky with only bright spots; start too early and you get a washed-out, white sky.

## Tips

- Use a remote or self-timer to trigger the shots to prevent camera movement.
- If shooting a public space or building, plan ahead so you know when nighttime lights come on.
- The "B" setting allows you to make really long exposures because it keeps the shutter open as long as you hold the button down—this is best used with a remote.

# Light Painting

This project is a little like "Squiggle Drawing" and a little like "Blur" except here the camera is stationary and we move the light around on the subject. During a long exposure, the camera sensor will record any light that hits the subject. We will use really long exposures so you can actually paint the subject with a flashlight.

- flash off
- PAS: Check your manual for a long exposure setting, sometimes it's called "night-time mode."
- DSLR: "B" setting works best if you have a remote that will lock the shutter open for as long as you want. Alternately, use the self-timer function and the longest shutter speed.
- smartphone: Skip this lab.

> "It's a small world, but I wouldn't want to have to paint it."
>
> —Steven Wright

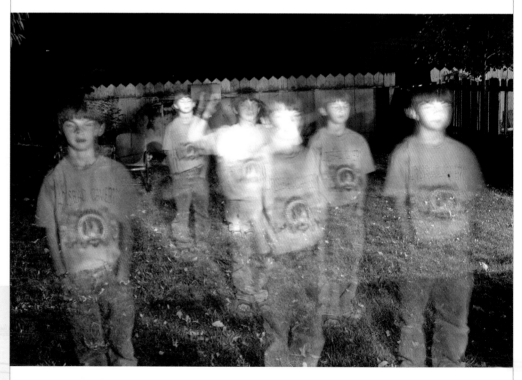

*To create this shot, I had Wes freeze in one spot after another while I shined a large flashlight all over him during a five-minute exposure.*

# Let's Go!

1. Choose your subject: a person, a house, a car, or a still life—almost anything.

2. Set up your camera on a tripod in a mostly dark environment, indoors or out. A backyard at night with all the house lights off will work. Any ambient light will affect the shot, but this can work to your advantage if you want to show the environment.

3. Set the camera to the slowest shutter speed you have or "B" if you have a locking remote. The camera light meter is pretty much useless in this situation because you will be adding the light during the actual exposure, so start with f/8 as your aperture and experiment to see what works.

4. Use a flashlight or lamp that projects light onto your subject in a focused beam

5. Shine the light onto your subject or scene and focus manually before taking your first shot.

6. Set your timer or remote, open the shutter, and "paint" your subject by moving the light.

## Tips

- Keep the light moving.
- The distance from the light to the subject will affect brightness, as will the length of time the light shines in one spot.
- Wear dark clothing if you don't want to show up in the shot.
- Light the subject from multiple angles and positions.
- Don't give up too soon. It may take you several attempts to figure out what works best.

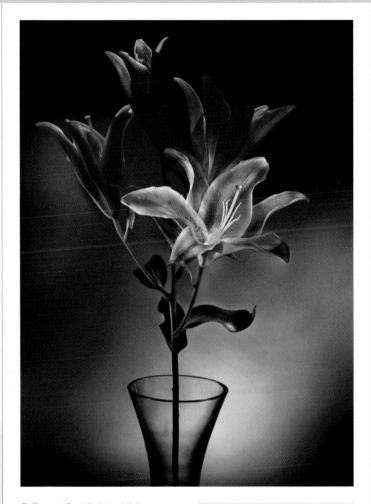

*Different flashlights yield different results. For this shot, I set up in a completely dark room and used a small focusing flashlight. During the thirty-second exposure, I moved the beam of light around the subject and on the background.*

# 43 Bokeh

- flash off
- PAS: Find a manual setting that gives you aperture control and use your widest aperture. Alternately, use a portrait or macro mode.
- DSLR: Use manual mode or an aperture priority mode and set to the widest aperture.
- smartphone: Great effects are possible with some of the apps available, such as Instagram.

*Bokeh* comes from the Japanese word *boke-aji*, for blur. The term itself was popularized in the late 1990s in the United States of America, but the effect has been a science since the beginning of photography. Basically, it applies to the pleasing effect of out-of-focus areas in a photo, mostly in the background. Whenever you shoot with a very wide aperture and focus on something close, you create *bokeh*. In this lab, we look at other ways of creating selective focus blur.

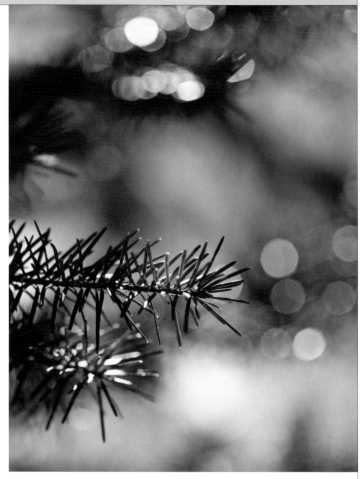

The word bokeh *describes the pleasing effect of unfocused light in a photograph.*

"*A picture is a poem without words.*"

—Horace

# Let's Go!

*Softness can be in both the foreground and the background.*

You already know how to create *bokeh* by shooting wide open (Lab 14). Here are some techniques to experiment with that give you more options. Try these on your favorite subjects.

1. In the old days, portrait photographers would smear some grease around the edges of the lens to selectively blur areas of the image. I wouldn't suggest mucking up your lens, but you can purchase a UV filter (a clear-glass lens that screws on the front of your DSLR lens) and put petroleum jelly on that. Use a cloth to wipe away a clean area and see what happens.

2. Use the same technique we used in "Head Like a Hole" (Lab 40), but use clear plastic instead of paper. Stiff acetate works great or food wrap stretched across your "Blink!" frame (Lab 2). Vary the shape of the hole and distance from the lens. Telephoto zoom works better with this technique than wide angle.

3. Post production: Many of the new editing programs (such as Photoshop CS6) now have easy-to-use filters (tilt-shift) for creating selective focus in normal images. Both iPhone and Droid now have apps that make amazing images; search TiltShift Generator or Instagram.

*Special lenses, such as Lensbaby, are accessories for your camera that give you great control of areas you want blurred.*

## To Blur or Not to Blur

Like any technique, *bokeh* can be overused and quickly becomes cliché. Knowing when to use any effect is a creative decision that should come from your gut. Think about what you feel and what you are trying to say. *Bokeh* creates images with mystery and romance; use it only when it fits your message.

When used in a consistent way with the mood of the shot, you almost don't notice the effect. If the first thing you notice in a shot is the effect, then you have been too heavy handed.

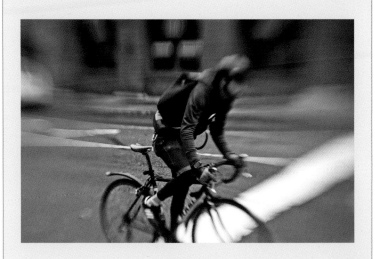

Materials

- photograph with the subject in front of a simple background
- sheet of t-shirt transfer paper for light fabrics, cold peel (such as Avery)
- small set of watercolors
- #12 round brush or similar
- inkjet printer
- paper cutter, or utility knife and ruler

*"Everything's intentional. It's just filling in the dots."*
—David Byrne

*Dots are good.*
*Dots are fun.*
*Now we dot another one!*

In Lab 19 we used t-shirt transfer paper the "normal" way and your image was transferred to another surface. In this lab we'll use the transfer paper as our canvas, and will paint directly onto it after printing the photograph. The reaction of the paint to the transfer material, along with the photograph, creates a unique hybrid piece of art.

*This dried flower petal was photographed on a textured piece of watercolor paper, which provided a subtle background perfectly suited for the watercolor dots.*

# Let's Go!

1. Find or shoot a photo with a subject in front of a plain background.

2. In your computer-editing program, size the image to fit on an 8.5 × 11 inch (22 × 28 cm) sheet of transfer paper and print it out.

3. Mix up a pool of watercolor using the color of your choice. Use lots of water; the paint should be very wet.

4. Load your brush with paint and carefully touch the brush tip onto the paper; repeat. After a minute or two, the paint will react to the transfer paper surface and begin to disperse. When you add more dots, be sure to leave enough room to account for this spreading (fig. 1).

5. Continue adding dots. Spread them out to create a wallpaper-like pattern or squish them close together to create a random texture.

6. Once the dots are dry, trim off the white edges (fig. 2) and mount your painted photograph on matte board.

## Tip

Print out an extra photograph and experiment with different colored dots on your background. For *The Screamer*, I experimented using black, blue, and green, before deciding on yellow.

**Fig. 1:** *Allow room between each dot for the pigment to spread. You can fill in areas later, if necessary.*

**Fig. 2:** *The pigment may spread outside the edges of the original photograph. To neaten, trim with a paper cutter or a utility knife.*

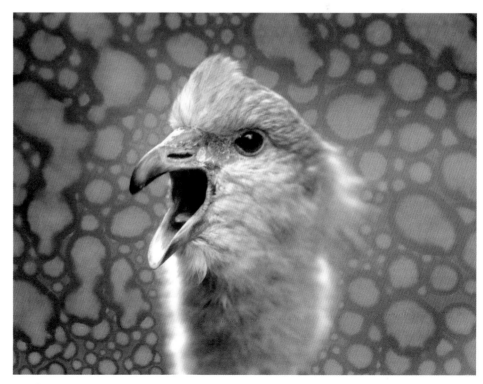

The Screamer, *mixed media on paper.*

# Deeper Waters

**IN THE LAST CHAPTER,** we worked on capturing some random photographs. Here we are stepping into images that are more thought-out, more crafted, and preconceived. The next group of assignments will put you in a position to create expressive images by making a deeper physical commitment: build something, approach someone, or go somewhere you haven't been before.

This is my favorite kind of shooting: Coming up with a concept or project, working out the logistics, gathering props and information, and then finally shooting. When you have to really dig in to get the shot, you open up many opportunities for discovery and new ideas.

As photography becomes a bigger part of your activities, you will go from a recorder of moments to a creator of moments. And the more you are involved physically and mentally with your subject, the more meaningful your images will become!

# LAB 45 Splat!

## Settings

- flash off
- PAS: Usa a close-up or macro mode.
- DSLR: Use a medium DOF and focus carefully. Make sure shutter speed is above 1/60 for a nice sharp image.
- smartphone: Make sure you are in a place with lots of light to avoid motion blur.

*"Art is a form of catharsis."*

—Dorothy Parker

Smash something (anything) and photograph it on a white background. Try to create a sharp, graphic image.

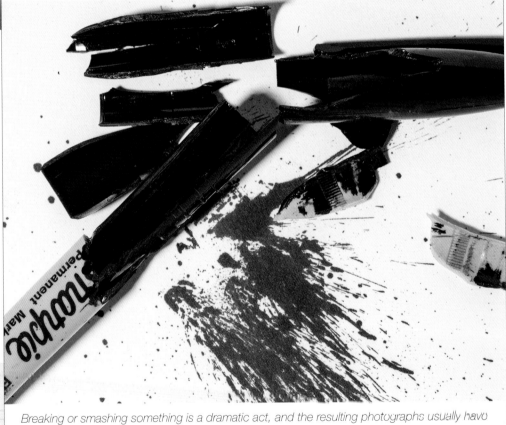

*Breaking or smashing something is a dramatic act, and the resulting photographs usually have lots of impact.*

# Let's Go!

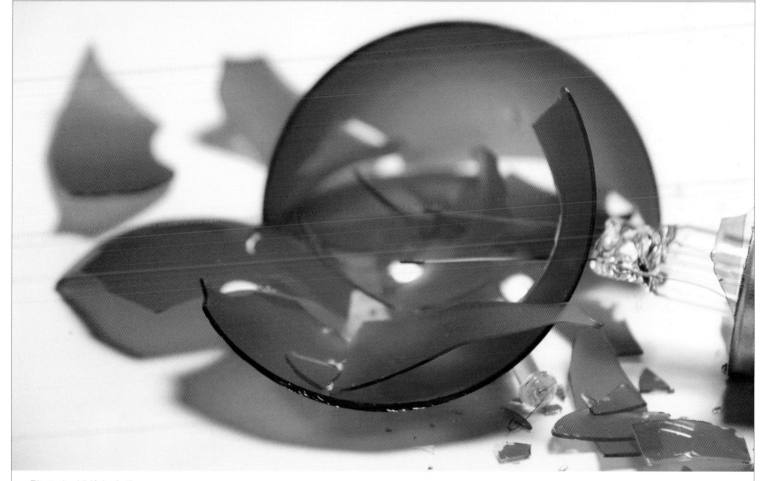

*Photo by Valérie Astier.*

1. Choose a white or light colored background—this could be paper, a table, a sheet, or something painted.

2. Set up near a light source that will produce nice hard shadows; a window with direct sun or a bare light bulb work best.

3. Smash, crush, or break something and take shots of the results.

4. Use a variety of camera angles from high (looking straight down) to low (closer to the surface).

5. Use exposure compensation to over- or underexpose the image to increase the graphic effect.

# Emulate Nonphotographs

Think about some of your favorite works of art: a painting, a sculpture, or a fictional story. Could they work as photographs? Your assignment is to deconstruct a nonphotographic piece of art and reproduce it as closely as possible as a photograph.

- tripod
- flash off
- PAS: Use a mode that fits your shot.
- DSLR: Manual exposure and focus are your best bet. Do tests and brackets before the final shot.
- smartphone: Prop your phone up between a stack of books or something similar so you don't have to reframe your shot every time you make a change.

*"Good artists borrow, great artists steal."*

—Pablo Picasso

*This assignment might require a trip to the local thrift store or vintage shop.*

Girl with a Pearl Earring *by Johannes Vermeer, c. 1665.*

Photo courtesy of Alamy.

Bethany with a Pearl Earring *by Christi Sonheim, 2011.*

1. Try to match every detail: camera angle, lighting, depth of field, color, and so on. Take several test shots and look at them on the computer before shooting the final shots.

2. It might be helpful to break down your production process.

Day 1: Select your image, scout your location, and find props and/or model.

Day 2: Do test shots, fine tune lighting, and sketch out poses.

Day 3: Set up and shoot finals.

# Picture in Picture

- flash off
- PAS: Use a landscape mode and the lowest ISO setting.
- DSLR: Use manual mode and a faster shutter speed. Use a low ISO so the image is not grainy. You want a very sharp image.
- smartphone: This is fun because you can do all the zooming right on the screen.

*"Objects in pictures should so be arranged as by their very position to tell their own story."*

—Johann Wolfgang von Goethe

There is so much detail in a single photo. As you look closer and closer at an image, you might begin to see other layers and other stories beyond the obvious.

*I discovered this little story buried within the beach scene, opposite.*

# Let's Go!

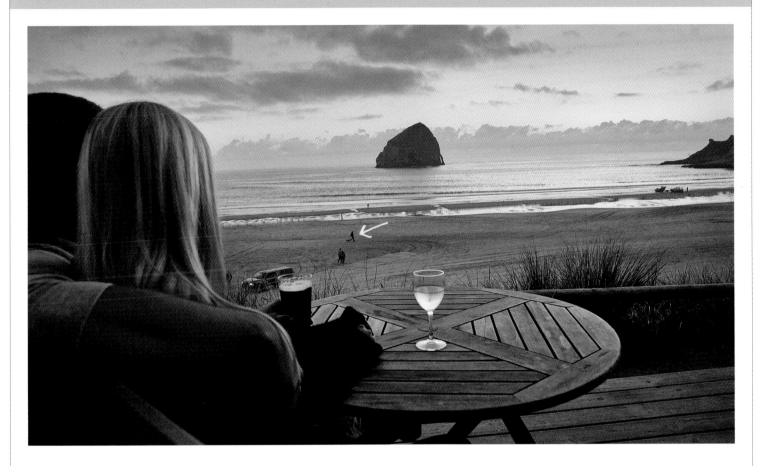

1. Go out and shoot a scene (or find one in your files) that includes as much of the world as you can: for instance, a city scene full of people, a beach, or a sweeping landscape.

2. On the computer, make a copy of your image so you don't mess up the original.

3. Pick an interesting shape or subject and zoom in until you have a completely new image.

4. Crop your selected area and then resize it by going to the "image size" or "resize" menu of your photo-editor and type in the rough dimensions and resolution (ppi) of your original shot (for example: 400 × 600, 180 ppi). This will give you a grainy but nonpixelated image.

5. Make three or more of these zoomed-in slices and put them together to create new stories.

# Seriously?

- If you still have a film camera, dig it out and buy some film (which is an interesting exercise). If not, borrow a camera or go buy a disposable film camera.

Digital technology has revolutionized photography by making it easier to take better pictures. Plus, you always have a camera with you, you never run out of film, and you can see your shots right away. This has changed not only how we take pictures, but also how we think about photography. For this exercise, we will step back in time and shoot on film.

*"Computer photography won't be photography as we know it. I think photography will always be chemical."*

—Annie Leibovitz

## Let's Go!

1. Shoot a whole roll of film on the topic of something you love. This should be the exact opposite of Lab 31 ("Hate It").

2. All of the terms we use in digital photography come from the days of film. Exposure, shutter speed, aperture, and depth of field all work the same.

3. Using a manual film camera is a great way to add to your understanding of exposure because the controls are relatively simple and force you to think about what is really going on.

4. When you get your pictures back, study them and think about how they are different from looking at files on your computer.

*On the road toward becoming more expressive photographers, this detour is intended to slow us down so we can think about our images independent of our electronic gadgets.*

# LAB 49 Abstraction

Settings

Creating abstract photographs can be challenging because it is the very nature of photography to be representational and capture reality. You have already created some abstract images with "Squiggle Drawing" or "Blurs." Because every image is a series of decisions, intentionally creating abstract photos is an important part of understanding the expressive nature of photography.

- PAS: Pick a mode that fits your situation.
- DSLR: Use full manual mode and allow yourself to go beyond what the camera tells you. Exposure mistakes can often result in abstraction.
- smartphone: Try a black-and-white app for this lab.

*"There is no abstract art. You must always start with something. Afterward you can remove all traces of reality."*

—Pablo Picasso

*A found abstract image.*

# Let's Go!

Create an image that is made purely of line, form, and color in one of the following ways:

**1.** Build an abstract image by gathering a collection of objects that hold visual interest for you. Assemble them in a design by doing whatever feels right, as if you are making a sculpture. Look for interesting intersections, contrasts, line, and form. To help remove the representational clues, shoot straight down, use motion-blur, or shoot out of focus. You can also use multiple hard light sources from low angles to create deep shadows.

**2.** Find an abstract image by looking at the world around you only in terms of line, shape, color, texture, and contrast. Design your images based on what looks interesting to you, rather than composing images based on making visual sense. Look for places with hard, contrasty light; sunset is a good time. Backlighting is a useful tool, or shooting directly into the light source and creating lens flare can be interesting. Moving in very close or looking at things from a great distance is a good way to see the abstract pattern in everyday objects. Remember, you are making an image that is essentially about nothing and is just beautiful itself.

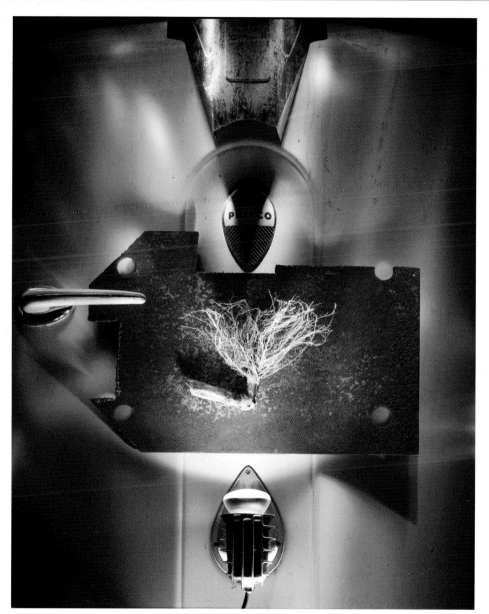

*A created abstract image.*

# 50 25 Strangers

If you love people photography, it's time to challenge yourself. Taking pictures of people you don't know is where the rubber meets the road in terms of photography as a social art form. And the image is only the beginning; your camera becomes a catalyst for unexpected connections.

- flash off
- PAS: Use a portrait mode.
- DSLR: Use an auto mode or an aperture priority mode. Practice beforehand with whatever settings you choose; don't get distracted in the heat of the moment.
- smartphone: This assignment can be challenging. People tend to be more suspicious if you want to photograph them with your phone.

*"There are no strangers here; only friends you haven't yet met."*

—William Butler Yeats

## Let's Go!

1. Photograph twenty-five strangers.
2. This could be twenty-five by the end of the year, or one new stranger per week or month, and so on—whatever you think you can accomplish. In any case, this should be a long-term project.
3. Talk to your subjects and engage them by asking permission and telling them what you are doing. These shouldn't be done surreptitiously: you need to become a part of the image.
4. Bring a notebook to record time, place, and their names. Having a business card to hand out also helps break down barriers.
5. Listen first; be patient and try to draw out their story. Actually taking the shots should be the last thing you do, not the first.

*Look for natural photo situations. Tourist areas or events work well, or places where people are at leisure and more likely to talk to strangers.*

# Lose Yourself

First impressions can drive our whole experience of a new place. In this lab, you will try to capture those initial feelings in your images. To do this, you will need to go somewhere you've never been with the singular purpose of taking pictures.

- PAS: This assignment is an opportunity to experiment with some of the other creative modes on your camera. Do some test shots and pick something that matches your feelings about the place.
- DSLR: Use a mode that you feel most comfortable with and have the most creative control.
- smartphone: This assignment is a good opportunity to use some of the cool apps available, such as Instagram.

*"Not all who wander are lost."*
—J.R.R. Tolkien

*Go far enough from home that it takes a special trip to get there.*

# Let's Go!

To get the most out of your adventure, stick to these parameters:

1. Go someplace you have never been and have limited knowledge of.

2. Go alone or with another photographer doing the same assignment.

3. Make it an exclusive trip just for taking photos; no other errands or agenda.

4. Allow yourself several hours of unstructured time to explore.

5. Start shooting as soon as you get out of the car, train, or off your bicycle.

6. When something catches your eye, shoot it right away and then dig deeper and take more shots. Move around to find different light and backgrounds. Step close or move back, work the shot, and then move on.

*These are shots taken on an afternoon walk through the French Quarter on my first visit to New Orleans, Louisiana.*

# 52
## Mixed-Media Project with Carla:
# Abstract Painting

- digital photographs
- painting media of your choice

"*Abstract painting is abstract. It confronts you. There was a reviewer a while back who wrote that my pictures didn't have any beginning or any end. He didn't mean it as a compliment, but it was.*"

—Jackson Pollock

I've always envied abstract painters, especially those able to create abstract imagery completely from their imaginations. I've tried, but I just can't seem to crack that nut. So when playing around with abstraction, I turn to my photographs to help me out.

*The camera allows you to try out many different abstract compositions very quickly. This series of shots was taken with my smartphone while eating dinner at a Thai restaurant with friends.*

# Let's Go!

Rose Petals in the Thai Restaurant, *watercolor and collage on paper by Carla Sonheim.*

1. Keep a digital-inspiration folder. Go through your photo files and put any that might be inspiration for abstract paintings in a folder. If your impulse says to put something in the folder that isn't strictly abstract in nature, do it anyway. The more the better!

2. Keep your eyes open. When out and about with your camera, look for abstract photo opportunities to add to your ongoing file folder.

3. Refer to your folder often. Spend time really looking at each file, asking yourself questions: Why do I like this particular shot? Would I like this one better if I took out this line?

4. Move things around. If desired, play around in your photo-editing program and try obscuring, adding, or moving elements in the photos to improve the composition.

5. Make a series of quick, small sketches from your photographs, trying out different compositional variations. Sometimes the act of physically drawing the image can help determine if they work.

6. Begin a painting with a photo or thumbnail sketch in mind, but always be ready to abandon the original if that is where the painting takes you.

# Glossary of Terms

**Aperture:** Aperture is like the iris in our eyes. It controls the quantity of light reaching the sensor and therefore controls exposure; it also affects depth of field. See **F-stop**.

**Brightness range:** This is the difference between the lightest and darkest part of a scene.

**Camera angle:** This is the physical height of the camera for a shot.

**Depth of field:** This is the range of focus from foreground to background. Our eyes have shallow depth of field. Small apertures create wide depth of field.

**Direction (light):** This is the position of the dominant light source relative to the subject.

**Exposure:** Exposure is the overall brightness of an image. We control exposure with a combination of aperture and shutter speed.

**Exposure compensation:** This is a feature on most cameras that allows you to increase or decrease expo-sure (brightness) while remaining in an automatic exposure mode. It is useful when the auto-exposure is not giving the desired results.

**F-stop:** This is the unit describing the aperture setting. For example: f/2.8, f/4, and f/5.6. Small number = large aperture. Each whole unit represents twice the amount of light as the previous unit.

**File:** This is the digital information that makes up an image. You can have multiple files of the same image.

**Frame:** This is the rectangle formed by your viewfinder or screen.

**Image:** The photograph recorded by the camera is called the image.

**ISO:** ISO indicates how sensitive film or a digital sensor is to light. A low number, such as 100, means more light is needed to make an image and the quality is higher. A high number, such as 400, means less light is needed to make an image but the result is a grainy, less clear image.

**Mode:** This is a setting designed for a specific subject matter or situation. The camera prioritizes shutter speed, depth of field, and ISO to give the best image.

**Noise:** This refers to the graininess that occurs in images shot at high ISO values. It also appears in dark areas of long exposures and images that have been highly manipulated.

**Resolution:** Generally, resolution is a measure of image quality based on the number of pixels per inch (ppi) relative to the viewing or output device. Computer screens are typically 72 to 100 ppi, and quality printers are 300 ppi and higher.

**Scene:** Whatever is in your frame is referred to as the scene.

**Shot:** A photograph at any state from conception to final print is called a shot.

**Shutter speed:** This is the actual measurement in fractions of a second of how long the shutter stays open during exposure. For example: 1/60, 1/125, and 1/250 second. Each successive whole unit represents half the amount of light (one stop) reaching the sensor. It also affects moving objects blurring in the image.

**Situation:** This refers to the natural or existing light in the place where you are about to shoot.

**Stop:** This refers to a whole unit of aperture or shutter speed and equals twice the amount of light as the previous unit. For example: 1/125 lets in twice as much light as 1/250 and is one stop brighter.

**White Balance:** This is the process of matching the camera setting to the available light source to ensure that all colors are reproduced naturally and normally.

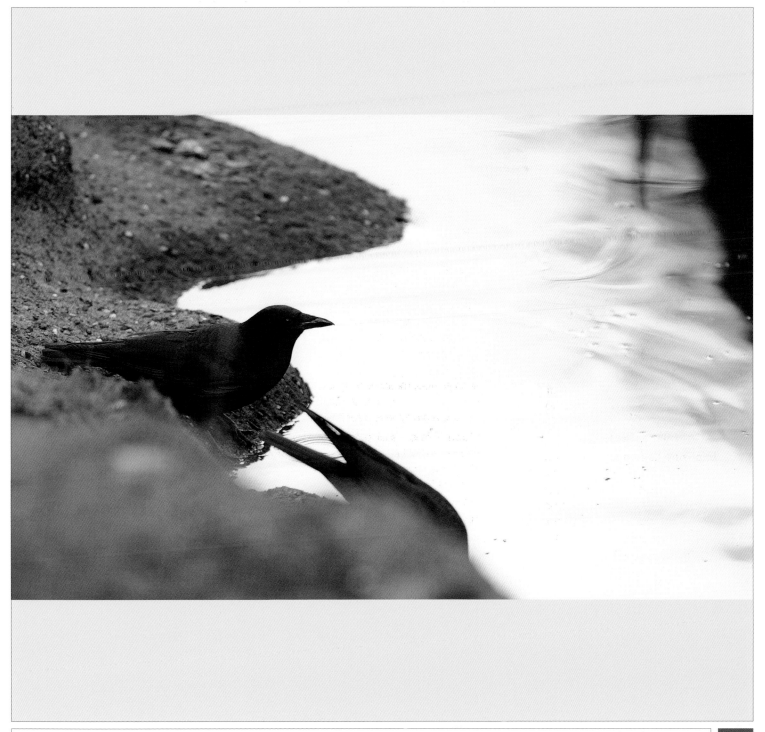

# Contributing Artists

**Angie Allen**
www.angieallen.com
Lab 38

**Valérie Astier**
www.val-photography.com
Labs 33, 40, 45

**Faith Berry**
Lab 8

**Anni Christi**
alyzen48.wix.com/anni-christie
Lab 33

**Kerstin Kumpe**
k.kumpe@googlemail.com
Lab 40

**Natalie Love**
Lab 6

**Cheryl Razmus**
cherylrazmus.blogspot.com
Labs 5, 32

**Christer Sonheim**
Lab 11, 20

**Christi Sonheim**
Labs 4, 11, 15, 16, 20, 39, 46

**Wesley Sonheim**
Lab 7, 27

**Karine M. Swenson**
www.karineswenson.com
Lab 1

**Grace Weston**
www.graceweston.com
Lab 21

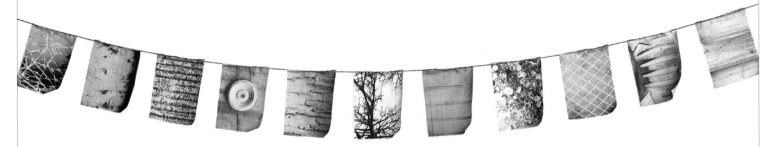

# Acknowledgments

**Special thanks to the following:**

- Christi Sonheim, for all her great shots and help in dreaming up these labs
- Mary Ann Hall for her patience and support
- Quarry Books
- All the wonderful models
- The contributing photographers and online students from "Photo Silly"

# About the Authors

**Steve Sonheim** has been a commercial photographer for twenty years. He has a BS from Brooks Institute of Santa Barbara and currently lives in Seattle. He believes photography should be more of an expresive act than a technical act. He tries to incorporate that philosophy into his work, which these days includes hotels and luxury resorts, people, and food.

He shares a studio with his artist wife, Carla, where together they produce online video courses in drawing, painting, mixed-media, and photography ("Photo Silly").

steve@sonheimcreative.com

www.sonheimcreative.com

**Carla Sonheim** is an illustrator and the author of three books: *Drawing Lab for Mixed Media Artists: 52 Creative Exercises to Make Drawing Fun, Drawing and Painting Imaginary Animals: A Mixed-Media Workshop,* and *The Art of Silliness: A Creativity Book for Everyone.*

carla@carlasonheim.com

www.carlasonheim.com

# Also Available

**Drawing Lab for Mixed-Media Artists**

*by Carla Sonheim*

**Drawing and Painting Imaginary Animals**

*by Carla Sonheim*

**Paint Lab**

*by Deborah Forman*

DEC 1 1 2017

771 SONHEIM
Sonheim, Steve
Creative photography lab :
  52 fun exercises for
  developing self
  expression with your
  camera
R0120603471          DOGWOOD

DOGWOOD
Atlanta-Fulton Public Library